IMAGES
of America

ITALIANS
OF BROOKLYN

ON THE COVER: Saint Finbar Catholic Church First Communion candidates are processing through the streets of Bath Beach, Brooklyn. (Courtesy of Saint Finbar Catholic Church.)

IMAGES
of America

ITALIANS
OF BROOKLYN

Marianna Biazzo Randazzo

ARCADIA
PUBLISHING

Published by Arcadia Publishing
Charleston, South Carolina

Printed in the United States of America

Library of Congress Control Number: 2017945457

For all general information, please contact Arcadia Publishing:
Telephone 843-853-2070
Fax 843-853-0044
E-mail sales@arcadiapublishing.com
For customer service and orders:
Toll-Free 1-888-313-2665

Visit us on the Internet at www.arcadiapublishing.com

In memory of my brother Frank Joseph Biazzo,
a Brooklyn Italian all of his life.
1963–2017

CONTENTS

Acknowledgments 6

Introduction 7

1. The First Generation 9

2. Churches and Societies 21

3. Work and Play 51

4. Patriots and Heroes 79

5. The Neighborhood 93

6. Family and Friends 113

ACKNOWLEDGMENTS

Italians of Brooklyn has been a labor of love. The experience of growing up Italian in Brooklyn for almost 50 years has fueled my passion for such a project. It is a collaboration in the fullest sense of the word. It would not have been possible but for the generous input of so many enthusiastic people who gave their stories, photographs, and time in countless ways. They have made this book possible.

Thank you to my editor Liz Gurley for patient and consistent guidance throughout the entire process, and to Arcadia Publishing for understanding the importance of remembering Italian Brooklyn history. Finally, thank you to my family: my husband, Gaspare, who is always at my side, making sure I eat and drink, laugh, and sometimes rest; and my children and grandchildren for keeping me grounded—they are the joys of my life. Thank you to my parents, who brought me to Brooklyn when I was 18 months and made it my home for 50 years. Thank you to my brothers, Conrad and Frankie, my first friends in my Italian family.

Special thanks to my friend, the archivist of Saint Finbar, Eileen LaRuffa; Rev. Guy Sbordone, pastor of Saint Frances Cabrini Church; and Joseph Rizzi, director of external affairs of the Federation of Italian American Organizations. They opened the doors, not only to church and neighborhood history, but also to my past as well. This book is not comprehensive—the history of the Italians of Brooklyn is too rich and complex to include in one small book. I have tried to capture the heart and soul of what life was and still is for Italian Americans who have had the Brooklyn experience. I have also attempted to show the progression of the immigrant experience in America: the pains, the joys, and the passions. Therefore, this book should not be considered a complete history, only a lens into a time and place dear to my heart.

INTRODUCTION

This book is a tribute to Brooklyn, New York, for its insurmountable power of assimilation. In addition to economic opportunities, Brooklyn defines acceptance in the truest sense of the word. Brooklyn's influence on her children, regardless of their nationality or year of arrival, has been dominant. No one walks away from Brooklyn without a part of it embedded in their soul. Without the contributions of immigrants from all parts of the world, Brooklyn would not be what it is today. By the end of the 19th century, more than one million people lived in Brooklyn, and more than 30 percent were born in another country.

Italians are by no means new immigrants. They were one of the first groups that settled in the land that is today the United States of America. An Italian discovered America; another gave her his name. As an Italian American, I could boast of Italy's rich cultural heritage; throughout history, they have bettered the world. Over the years, there were certainly well-educated Italians who closely identified with Italy's glorious history of art, culture, science, and literature, but the number of well-educated Italians who came to settle in New York City during the time my grandparents migrated was small compared to the number of peasants. In Italy, as in other countries, the well-fed, well-dressed, and well-educated seldom have a need or desire to find a new homeland. More than half of the southern Italians who arrived in America early in the 20h century could neither read nor write. We are proud of the artistic, scientific, and musical contributions made through the times to the world, but equally significant are other gifts. Our history is one of many years of hard, backbreaking work. Italian Americans are industrious, God-fearing, family-loving people. And this today is a rich cultural heritage. Over 100 years ago, Italian benevolent societies assisted and fought for the rights of Italian Americans. Today, organizations like the Order Sons and Daughters of Italy in America represent the estimated 26 million Americans of Italian heritage. They are dedicated to promoting our culture, our traditions, our language, the legacy of our ancestors, and our contributions to the United States and the world. The Commission for Social Justice is the anti-defamation arm of the Order Sons and Daughters of Italy in America. Founded in 1979, it fights the stereotyping of Italian Americans by the entertainment, advertising, and media industries. It also collaborates with other groups to ensure that people of all races, religions, and cultures are treated with dignity and respect.

I hope that as we always remember to celebrate our fellow Italian Americans, whose actions and thoughts we admire, we exhort the youth of America to emulate those strong, creative personalities.

The pictures in this book are from those who know best: the daughter of the iceman, the granddaughter of the shoemaker, the founder of the National Organization of Italian American Women, the Federation of Italian American Organizations, and many other current and former inhabitants.

In collecting the photographs for this book, the emphasis was on Italian American life in Brooklyn, but I discovered that each image took me on an unexpected, sometimes shocking,

historical, cultural, and emotional journey. In these pages, there are many moments of joy and celebration, but there are also moments that witness the historically unspeakable in the Italian American experience. In a culture that held sacred the principle of silence and believed that the experiences of the family be hidden and unexpressed, it has taken almost 100 years for truths to be revealed. Of course, with modern technology and the internet, it is difficult to keep secrets for too long anymore.

Against all the odds, poverty, language, ethnic slurs, and prejudice, Italian Americans paved the streets, built the bridges, sewed the dresses, and did all manner of backbreaking work to live in "L'america," the land of opportunity and achievement. Some immigrants experienced success in their lifetimes; others were not so fortunate. Second-, third-, and fourth-generation Italian Americans may be enjoying the fruits of their labor, hopefully appreciating the sacrifices and hard work that made their education and prosperity possible today.

These personal accounts and photographs of Italian American families that have passed through or still live in Brooklyn tell inspiring and courageous stories. They speak of getting through immigration, finding jobs and a place to live, and learning new ways of doing just about everything. They also reflect on the joy of their new-found home, being embraced by the Brooklyn community and fellow Italians with incredible senses of humor, an intense appreciation of music, and a greater appreciation of good food. They prove that in time, old traditions, philosophies, and customs embraced the streets and people of Brooklyn. This book, through photographs, tells the stories as described by the children and grandchildren of those early immigrants with a few modern-day stories of today's Italians of Brooklyn. It is nice to see how family pride and strong ties to the old country survive even today.

I grew up in "Bruculinu," as my Sicilian ancestors called their Brooklyn neighborhood during the mid-20th century. Although my parents worked hard to give my brothers and me a perfectly typical American way of life, they instilled in us Italian customs and an appreciation of our heritage not through history lessons but through example. These photographs are the testimony of Brooklyn Italians past and present, famous and unknown. It depicts what it was like when a deal was made with a handshake during the early part of the century and now, when Brooklyn has come back to a surprising and inspiring renaissance. The story of the Italians of Brooklyn is one of the remarkable and still unending chapters of the American urban experience.

—Marianna Biazzo Randazzo

One

THE FIRST GENERATION

The American dream was not easy for Italian Americans. They accepted jobs that were often on the lowest rung of the occupational ladder, bypassing education in place of on-the-job training. Day-to-day needs were the focus of all their energy. From very humble beginnings, entrenched with determination, they rose to the top of American industry. Proud and thankful for their heritage, they made great strides for future generations.

Men like Antonio Santillo from Casapulla opened bakeries in South Brooklyn. During World War II, when sugar was rationed, he began baking and selling bread in his pastry shop at 690 Fifth Avenue. "Everyone needs bread," became his mantra. He was right. He subsequently purchased real estate and established family businesses.

Other Italians who did not operate businesses took jobs in other trades or factories. Frustration, resettlement, hard times, and low wages did not discourage the spirit of the Italians. When they had no church of their own, they built them. As the population of Italians grew, so did memberships of Italian non-profit organizations such as the Order Sons of Italy in America.

An Italian proverb states *Chi esce riesce*. ("He who leaves succeeds.") But it took lots of courage for emigrants to leave the villages where they had been born, to say goodbye to the *famiglia*, their source of love and security, and set out for a land that was nothing more than a legend to many peasants of the south. More than 95 percent of all Italian immigrants followed in the wake of Giovanni da Verrazano, arriving in New York City. They passed through the Narrows between Brooklyn and Staten Island, where the bridge named in Verrazano's honor stands.

From 1880 to 1930, New York City was one of the fastest-growing urban areas in the world. Italians helped construct its skyscrapers, bridges, tunnels, subways, and streets. Thousands dwelled in tenements on Mulberry Street, in a district known as Little Italy, but it was not able to hold them. When the Brooklyn Bridge was built in 1883, in part by Italian laborers, Italians used it to move into other neighborhoods across the East River in Brooklyn. That was just the beginning. These were the "first generationers."

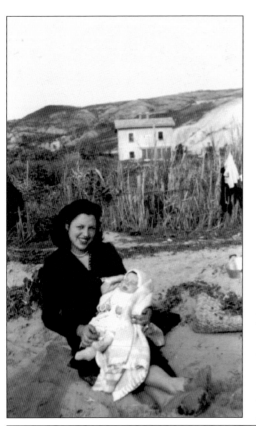

The Venuto family embarked on their journey to America from the village of Agrigento, Sicily. In 1967, Giovanni and Maria Venuto and six children boarded the *Raffaello* to New York City, where Giovanni contemplated the future of his family. In his heart, he knew it would be in music. (Courtesy of Liana Amodeo.)

Italian immigration peaked between 1900 and 1914, when two million Italians immigrated to America. Italy's government encouraged emigration to lessen the strain on its economy. The US government established passport requirements for immigrants in 1901; before that, no papers or permission were required. It created the General Immigration Office to oversee all facets of immigration. Italians had the lowest rate of rejection of any ethnic group entering America. (Courtesy of Marie Firiglio.)

— 2 —

Connotati del Titolare del Passaporto

Statura m. *1.61*

Età *anni 40*

Fronte *corta*

Occhi *cerulei*

Naso *aquilino*

Bocca *giusta*

Capelli *biondi*

Barba

Baffi

Colorito *bruno*

Corporatura *regolare*

Segni particolari

FIRMA DEL TITOLARE

— 3 —

Il presente passaporto è rilasciato per *New York a Genduso Damiana per tre anni. Rilasciato gratis a norma dell'Art. 6 comma 4° P. 2° 31 Gennaio 1901. Catania Due (2) settembre 1906. Il Questore*

destinazione.
ovvero fino al 1° aprile (per gli inscritti 1° gennaio per gli inscritti di leva marittima... (art. 5, comma 2°, del regio decreto 31... 901).

(3) Luogo per l'apposizione della marca speciale (o per la dichiarazione che il passaporto viene *Rilasciato gratuitamente a norma dell'art. 6, comma 4°, del regio decreto 31 gennaio 1901*), bollo, data e firma dell'autorità che rilascia il passaporto. Se si tratta di passaporto rilasciato all'estero, in sostituzione della marca speciale l'ufficiale che lo rilascia annoterà, accanto al bollo, l'ammontare della tassa percetta.

Married at 15, Camilla Cardillo Buonello bore six children before becoming widowed. She then married Joseph Murro, produced seven more children, and ventured to 912 Sixty-Second Street, Brooklyn. Carmela ran a *salumeria*, with fresh milk and eggs supplied by the goats and chickens kept in the yard. She made her son Danny (the little boy in dark clothes) wear the St. Anthony robe as gratitude to the saint for curing a severe illness. The boy grew to be a tall, muscular merchant marine. (Courtesy of JoAnn Colombo-Jarush.)

Frank Tedesco first settled in Roseto, Pennsylvania, before relocating to Brooklyn. As an immigration inspector (standing on the left) at Ellis Island, he awaited steamships that docked in Manhattan to allow first-class passengers off their ships. Immigrants in steerage waited for a ferry boat that took the ride to Ellis Island, where Tedesco assisted in the inspection process. After being tagged with numbers, and much pushing and shouting, immigrants were examined by doctors and immigration officials. Awaiting their fate, they listened for their name to be called. (Courtesy of Raffaella DeSanto.)

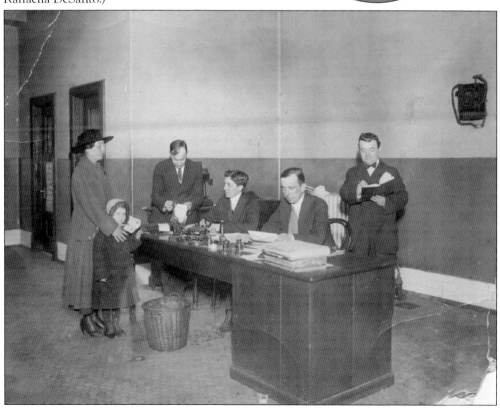

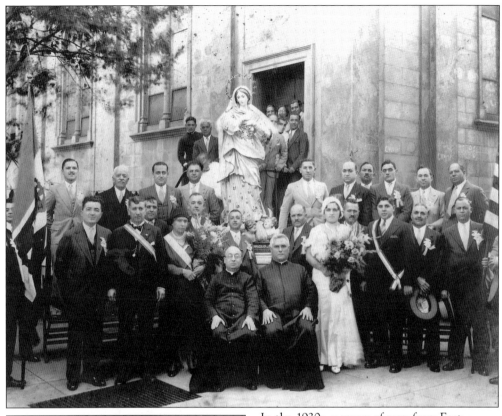

In the 1930s, a group of men from East New York formed the Circolo Immacolata Concezione to honor the patroness of Calitri. Thus began the celebration of the Blessed Mother's feast days at Our Lady of Loreto. The church, founded by Italians and completed in 1908, stood at the corner of Pacific and Sackman Streets at the border of Ocean Hill and Brownsville. (Courtesy of Mario Toglia.)

Andrew Pignataro was a longshoreman and co-proprietor of Talk of the Town Bar and Grill at 4624 Third Avenue, which catered to the Norwegian clientele of the neighborhood. Born in Salerno in 1883, he immigrated to America in 1902, settling on Garfield Place where fellow *paisani* (townsfolk) included Teresa Raiola, who gave birth to Al Capone. The young Capone became godchild to a member of the Pignataro family through his Baptism. (Courtesy of Adele Mautschke.)

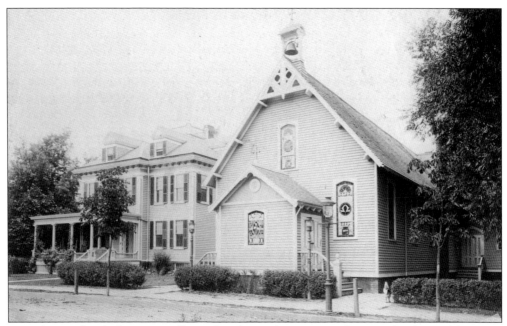

Sparsely populated, the 1880s village of Bath Beach was a seaside resort for the wealthy. Early Irish settlers founded the parish church, Saint Finbar. In the succeeding years, it became a haven for Italian immigrants. In 1893, a new building was proposed, and the church moved to the newly built edifice at Bay Twentieth Street. The church was completed in 1912, providing Italians with spiritual, physical, and community services. (Courtesy of Saint Finbar Catholic Church.)

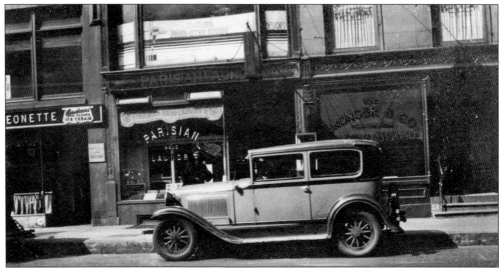

Despite obstacles, Italian immigrants gained a reputation for good business sense. Umberto Pizzini, an entrepreneur, worked his way through Europe, arriving in America by first class in 1925. A commercial artist, Pizzini designed Mamma Mia and Progresso olive oil cans. He lived in Bay Ridge, Brooklyn, with his family and worked in the city, conveniently parking his car outside the building. Umberto Pizzini's studio was on Lexington Avenue in New York. (Courtesy of Denny Pizzini.)

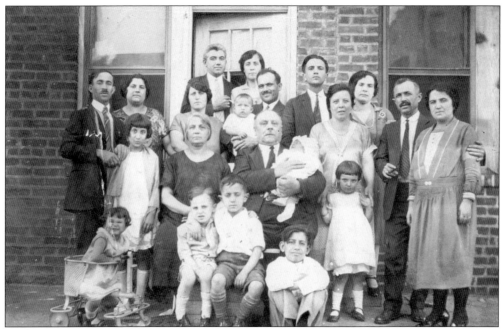

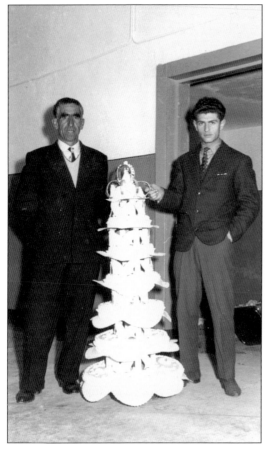

The Biazzo family and friends posed for a photographer in 1926 in Greenwich Village, pooling their pennies for payment. The new life in America did not please all of the southern Italians. Nearly half of the more than 4.5 million Italians who immigrated to the United States before 1924 returned to Italy. However, the wealth of returning emigrants continued to encourage mass departures. To escape the overcrowding of the city, families fled to Brooklyn. (Author's collection.)

When Vito Galifi, son of the mayor of the ancient city of Vizzini and owner of the bakery, married his childhood sweetheart Connie, it was appropriate that Vito and his father should create something fabulous. Although Connie had immigrated to America in 1954, she returned to Vizzini to marry Vito in 1957. Love letters and music sustained their love. Connie's dream was to marry in Sicily on a Sunday, but it was not permitted. She asked the bishop for special permission. Who could refuse the baker's future wife? After all, it was Vito who had baked the cake for the bishop's coronation. The senior Galifi was mayor for eight years. (Courtesy of Vito and Connie Galifi.)

Colandrea's New Corner Italian restaurant was founded in 1936, at 7201 Eighth Avenue. When Vincenzo Colondrea left Naples over 100 years ago, he took with him foolproof ingredients for success: determination, character, and a strong work ethic. With little education, his first job for 3¢ a day was to help his mother aboard ships docked in the Bay of Naples, germinating the seeds for success as a restaurateur. (Courtesy of the Colandrea family, New Corner restaurant.)

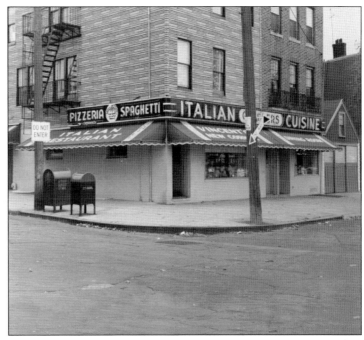

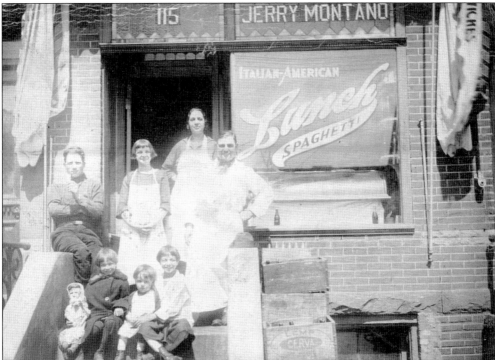

Jerry Montano's Italian-American luncheonette, at 115 Fifty-Seventh Street, was established in 1925. Here, the Montanos take a break from the lunch crowd a block away from the Brooklyn Army Terminal. Posing with them and annoying Mamma Lena was the iceman on the left, holding up his business card. The terminal was a government project that began in 1918 and served as a military depot and supply base. The lunch special was spaghetti. (Courtesy of Jerry Montana.)

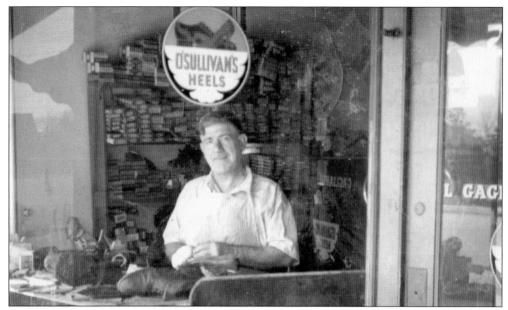

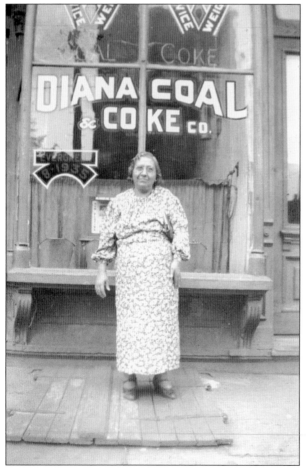

Gagliardi's shoe repair shop was located at 2311 Avenue Z. Lorenzo Gagliardi arrived in America and married Giovanna Esposito from Naples in 1917. They lived in Sheepshead Bay, the recreational fishing center. He enjoyed the bay, reminiscent of Italian life. A patriotic man, he proudly displayed photographs of Kennedy, Lincoln, and Washington in his shop. Tragically, his son lost his life during World War II at age 19. Brokenhearted, Lorenzo worked every day until his death in 1968. (Courtesy of Elizabeth Capelonga.)

Diana Coal and Coke Company, along with other coal companies, was established in 1935 at 3298 Atlantic Avenue by a family of five brothers and three sisters. Standing in front of the establishment is Josie Piazza. During the depression, Alfonso Piazza lost the company because of his kindness to customers. He provided coal to those who could not pay until he could no longer pay his own bills. The whole family continued to live in the building. (Courtesy of Tom Gulino.)

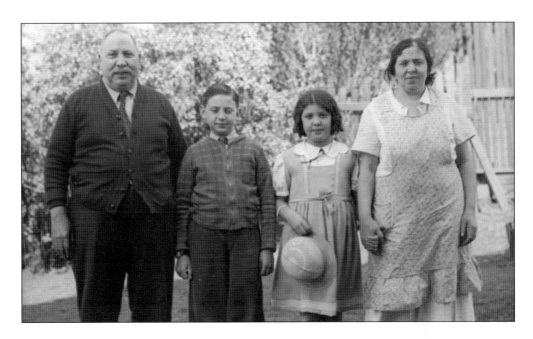

The Carbone family (above) take a break from the bar and grill to pose in the backyard of their establishment at Thirteenth Avenue and Sixty-Fifth Street. Below, Francesco Carbone poses with his children and friends. After serving in Africa at the turn of the 20th century, Carbone migrated to America. He promptly went west to work on the railroads. The experience taught him that the gathering places for socializing were the saloons. This led him to open a bar and grill in Brooklyn. In 1919, because of Prohibition, Francesco and his wife, Concetta, had the bar and grill converted to a candy store. Prohibition was repealed in 1933, and they restored the bar and named it Balbo, because at that moment, a squadron of airplanes led by Italo Balbo flew over during their circumnavigation of the globe, on their way to a stopover at Floyd Bennet field. (Both, courtesy of Gabriel Carbone.)

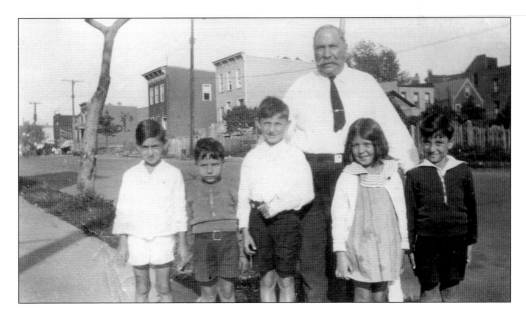

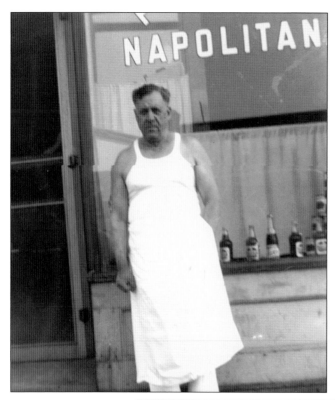

Antonio "Totonno" Pero is pictured standing outside a pizzeria around the 1950s. Pero became an employee at Lombardi's in Little Italy, New York. He began making pizza in a coal-fired oven, wrapping it in paper and tying it with a string. Because of his skills, Pero was the first *pizzaiolo* at Lombardi's, which became the first licensed pizzeria in America. Pero brought the Neapolitan pizza to America. In 1924, Totonno's Pizzeria opened at 1524 Neptune Avenue in Coney Island. Totonno's is the oldest continuously run, family-owned pizzeria in America. (Courtesy of Antoinette Balzano.)

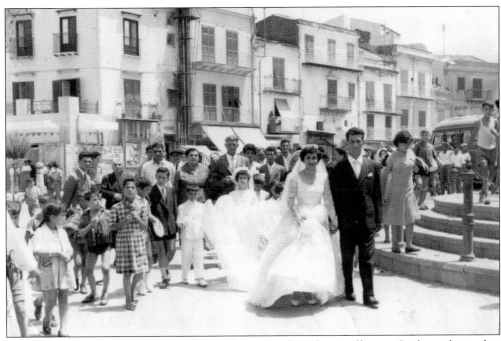

When Rosetta Pisano matched family friend Maria with a relative of hers in Sicily, a relationship began through letters, postcards, and photographs. Italian veteran Giuseppe Randazzo proposed to Maria Anna Corticiano, born on Hicks Street. Maria and Rosetta would travel to Sicily for the nuptials. On July 27, 1957, in the Commune of Carini, the whole town, invited and uninvited, participated in the wedding festivities. After three months in Sicily, husband and wife sailed home expecting their first of four children. By the 1950s, there were a sizable number of adult Italian American men and women who found spouses from Italy and sponsored their migration. The Italian American community blossomed in the postwar era, as Italian-born couples who had arrived in earlier decades expanded their families. (Author's collection.)

When Bari native Nicolo Squicciarini, the iceman, married Brooklyn-born Sophia Proscia in 1928, he gave her an extravagant wedding at the elegant and lovely Grand Prospect Hall in Park Slope. Despite their very modest income, it had become customary for the icemen to partake in elaborate affairs. (Courtesy of Squicciarini family.)

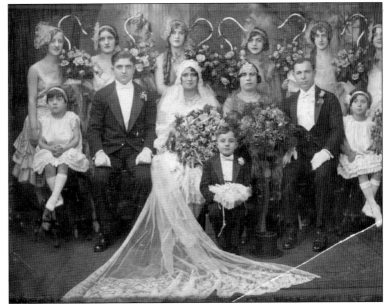

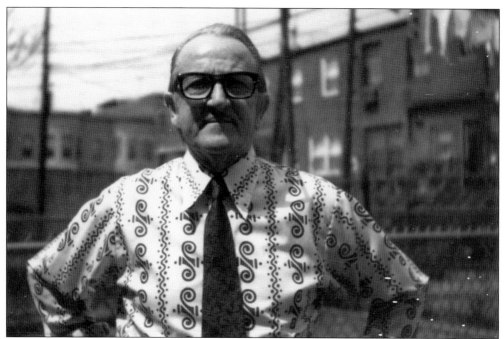

Emilio Giuseppe Dossena, a native of Cavenago d'Adda, was a brilliant impressionist. The necessity of providing for his family meant that he could only dedicate his spare time to the arts. His livelihood was earned by the restoration and decoration of villas and castles, in addition to producing frescoes for churches. He arrived in Brooklyn in 1968 and resided at 54 Cheever Place (above) in Carroll Gardens and was employed by Studio Berger. The accomplished artist restored works by Renoir, Rembrandt, Picasso, and other masters that were the property of museums and private collections. His clients included the Metropolitan Museum of New York (below) and the Playboy Club. (Both, courtesy of Tiziano Dossena.)

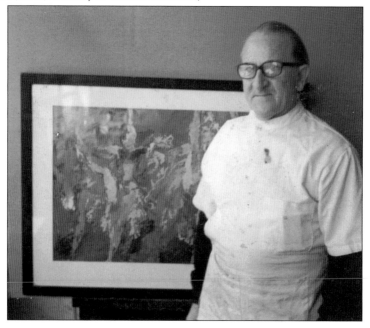

Two

CHURCHES AND SOCIETIES

The Catholic Italians who came to Brooklyn during the great wave of American immigration struggled to establish their own parishes, schools, and societies. They wanted Italian priests to preside at daily Mass and feast day celebrations, christenings, weddings, and funerals. Several of these institutions flourish to this day. There was something about the Italian Catholics of Brooklyn that set them apart from other Catholic immigrants. Southern Italian heritage developed from many different cultures. Catholicism became a mix of ancient values, concepts, and symbols. It evolved into a unique philosophy that helped Italian peasants cope with life's problems. They prayed to the saints for help with these challenges and found escape be celebrating their faith with festive parades, in which they carried statues pinned with money through the streets while musicians played and vendors sold food. Many of the colorful Catholic feast day celebrations that draw Italians and non-Italians to Brooklyn neighborhoods center around the church. Other organizations have helped to keep language, values, and customs alive. Despite instances of discrimination and exploitation, the Italians did not surrender their values and culture. Instead, they developed religious, political, and economic and social institutions to support them in adjusting to life in Brooklyn. Among these organizations is the Order Sons of Italy in America. The A.P. Giannini Lodge still operates in Brooklyn. The Federation of Italian-American Organizations (FIAO) assists individuals and families assimilate to mainstream society. Today, the mission of FIAO is to promote unity in the multi-cultural community. In years past, prominent Italian American men such as Vincenzo "Doc" Bruno, who owned a pharmacy on Court Street, was a key member of the Italian Benevolent Society of Sicily and chairman of the City Fusion. Italian religious institutions have played a key role in helping Italians preserve their culture, and social clubs still thrive in some Italian enclaves in Brooklyn. Throughout the decades, social clubs such as Society of the Citizens of Pozzallo in Carroll Gardens, Societa Figli Di Ragusa, Sciacca Social Club, and the Societa di Licodia Eubea, established in 1929 in Bensonhurst, have thrived. Mainly men gathered in these clubs over the decades, except when they were used for social gatherings or celebrations.

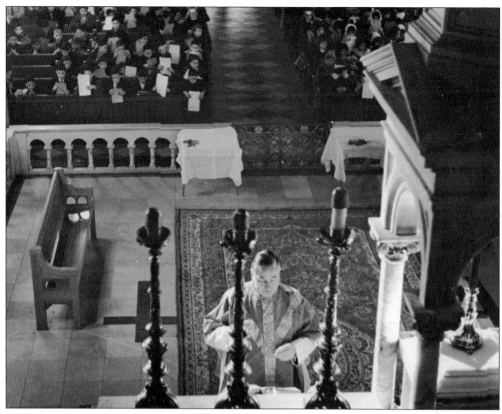

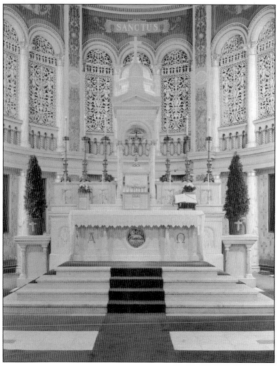

Saint Finbar's altar was made of marble and accommodated rows of parishioners awaiting Communion after hours of fasting. Magnificent stairs lead to the altar of this church that served thousands of Italian immigrants in the first half of the 20th century. By the 1920s, Italians from Little Italy and other parts of Manhattan began moving to apartment buildings in Bensonhurst, continuing well into the 1950s. In 1938, Masses in Italian brought in 700 parishioners a night. The confessional and altar rail were continuously crowded. (Both, courtesy of Saint Finbar Catholic Church.)

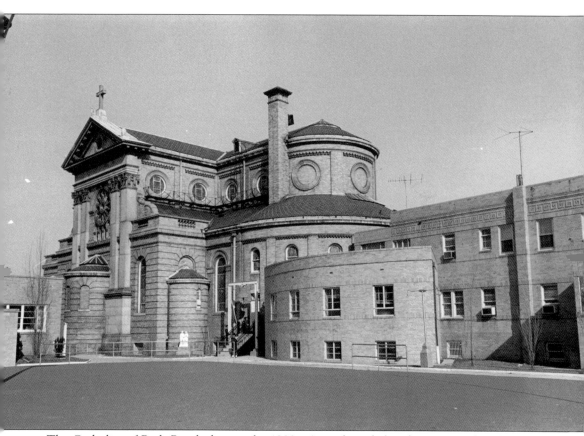

The Catholics of Bath Beach date to the 1880s. An enlarged church was turned to face Bay Twentieth Street in 1893. In the 1850s, Brooklyn was still an independent city where Italians were beginning to establish a colony. At the turn of the 20th century, the Irish Catholic clergy thought the flamboyant Italian customs attracted too much attention and ridicule. They pressured Italians to abandon public shows of religious fervor, traditions, and customs. The Italians responded by urging the church to establish separate Italian parishes. Italian immigrants joined together to create these parishes, raising money and donating labor to build churches throughout America. (Courtesy of Saint Finbar Catholic Church.)

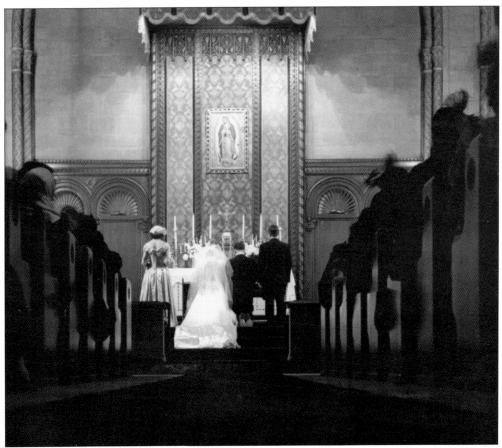

Erected in 1908, Our Lady of Guadalupe Church was home parish to Marie and Ed Lembo. Despite a fire in 1933, after receiving their sacraments there as children, the couple were married there in 1949, as were their daughters. The couple had their reception at the Riviera in Coney Island. A second fire destroyed the church in 1973, causing it to be rebuilt. The Lembos lived on Sixty-Fourth Street, across from the Angel Guardian Home, where the Sisters of Mercy built the campus in 1899 and operated an orphanage until the 1970s. By the mid-20th century, the church had developed an array of devotional practices. Many Italians embraced the Catholic institutions. Men joined the Holy Name Society and the Knights of Columbus in record numbers, women joined groups such as the Legion of Mary, and returning veterans joined Catholic War Veterans. These organizations created their own cultures. (Courtesy of Joanne Mantovani.)

Barbara Pascarella poses on the day of her First Communion across the street from Saint Theresa Chapel. Father Angelo Cioffi was assigned to St. Rosalia in 1923, and planned extensive renovations and additions. A chapel was added, and property was purchased at Twelfth Avenue and Sixty-Fifth Street, where a rectory, St. Theresa Chapel, and a new school were built. In 1938, Pope Pius XI bestowed the title of monsignor on Father Cioffi. (Courtesy of Barbara Pascarella.)

Outside Our Lady of Loreto, a Società Immacolata Concezione di Calitri group called Figlie di Maria ("Daughters of Mary") poses around 1930. Despite the reluctance of the American Catholic Church to welcome them, the Italian immigrants held firmly to their beliefs. (Courtesy of Mario Toglia.)

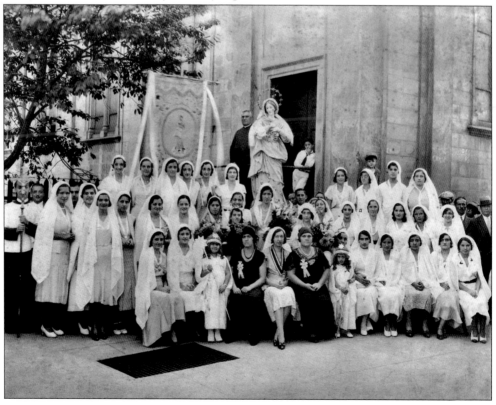

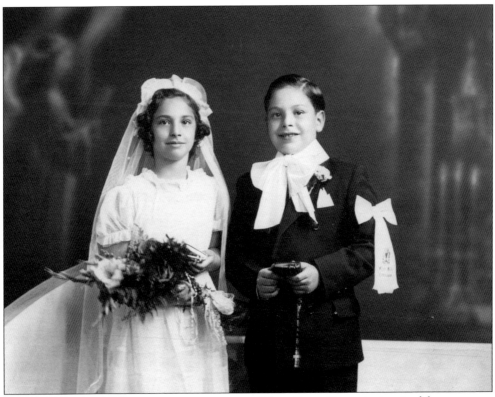

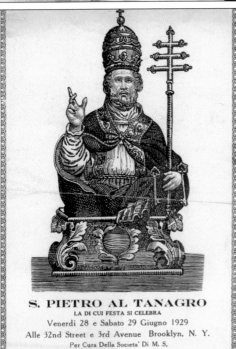

S. PIETRO AL TANAGRO
LA DI CUI FESTA SI CELEBRA
Venerdi 28 e Sabato 29 Giugno 1929
Alle 32nd Street e 3rd Avenue Brooklyn, N. Y.
Per Cura Della Società Di M. S.

SAN PIETRO AI TANAGRO
Panegirico e Messa Solenne, Sabato 29 Giugno, ore 10.30 a. m.
nella Chiesa di SAN ROCCO, alle 27 St. B'klyn, N. Y.

When Pietro Prestininzi arrived from Calabria in 1933, he visited friends of the family in West Virginia. There, he met Assunta Mettica, the oldest of nine sisters, and a match was made. The newly married couple moved to Bedford Stuyvesant, where he set up his shoemaker shop. Here, two of their four children receive Communion at Saint Ambrose Church on Dekalb Avenue in Bedford Stuyvesant around 1942. (Courtesy of Rose Prestininzi.)

Brooklyn Catholic life was a favorite topic in the New York newspapers. From Manhattan to Long Island, dailies and weeklies closely followed the church's progress. From 1841 to 1955, the *Brooklyn Eagle* ensured that Brooklyn Catholic news received national attention. Special events, such as the San Pietro Al Tanagro Feast at Saint Rocco Church, received much attention. (Courtesy of Saint Finbar Catholic Church.)

Daniel George, parish priests Reverend Father Donagan and Father Thomas Scanlan, and men of the Saint Finbar's Usher Society break bread together in 1941. Ushers of all ages welcomed parishioners and seated them in church during Mass. They also directed the congregation during Communion and orchestrated the collection of donations. (Courtesy of Saint Finbar Catholic Church.)

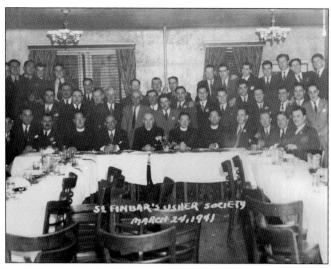

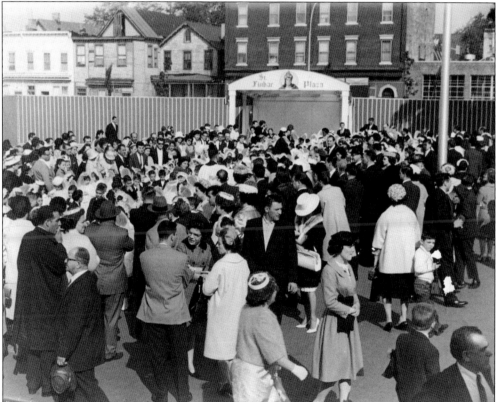

By 1934, during the Depression, people in the area were struggling to survive. The monsignor of Saint Finbar himself went out to help people with Home Relief, which was the welfare of the time. Soon, the congregation grew considerably. The bishop worked tirelessly to reconfigure the structure of the Diocese health-care system and to renovate facilities. Some of the institutions established during this era include the Itinerant Teaching Program for Blind Children, St. Francis de Sales School for the Deaf in Park Slope, and the Madonna Residence in Park Slope. (Courtesy of Saint Finbar Catholic Church.)

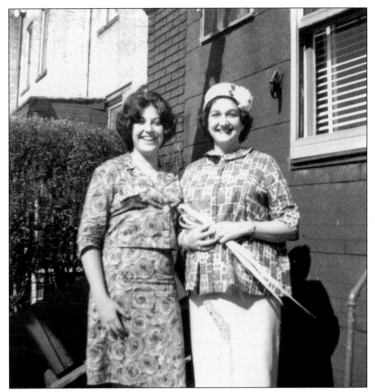

Sisters Jeannie Mancusi (left) and Gloria Filletta pose after Palm Sunday Mass, the final Sunday of Lent. Standing on East Second Street between Bay Parkway and Avenue J, they hold their newly blessed palms. The sisters then joined the rest of the family for Sunday dinner. The day marks the beginning of Holy Week. (Courtesy of Commandatore Aldo Mancusi.)

Marie Corticiano of Hicks Street was raised in the Church of the Sacred Hearts of Jesus and Mary. Her first formal photograph was of her First Communion in 1941. Formal photographs were taken to show relatives on the "other side" the experiences they were having and how they were living. At the beginning of the 20th century, the Brooklyn area held the largest concentration of Italians in the country. Demolition destroyed the brick Italian church built by dedicated Italian immigrants to make room for the Brooklyn Queens Expressway. On the same day that the Japanese attacked Pearl Harbor, the final Mass of Sacred Hearts of Jesus and Mary Church was celebrated. The parish's Italian societies processed, with the statues of their patron saints held high, through the streets to their new home at Saint Stephen's Church. (Author's collection.)

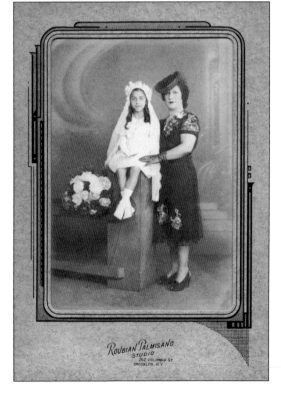

Reverend Father Paul Klohr applies ashes to a parishioner at Saint Finbar on Ash Wednesday. It is an important holy day in the liturgical calendar and opens Lent, a season of fasting and prayer. When receiving ashes, a priest or minister may say, "Remember that you are dust, and to dust you shall return." (Courtesy of Saint Finbar Catholic Church.)

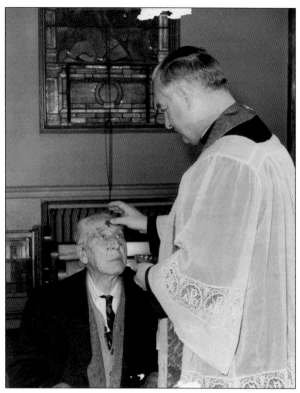

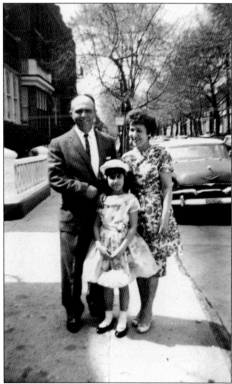

Janice Colombo poses with her mother and father on Fifty-Eighth Street before joining the family for dinner. Tradition had it that all the children would receive a new outfit for Easter Sunday. Next, the whole family, several dozen relatives, would meet up at their grandfathers' house. After large meals, adults played cards, while children played. JoAnn Colombo remembers, "it wasn't only on Easter that the clan gathered—it was every Sunday!" (Courtesy of JoAnn Colombo-Jarush.)

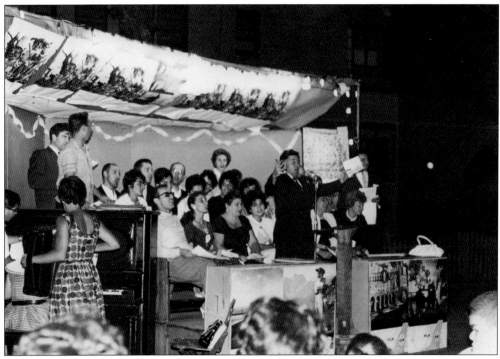

In the 1950s and 1960s, Saint Finbar's theater groups and singers were top-rated for their entertainment, according to the *Brooklyn Eagle*. Italian-themed entertainment was the most popular of all immigrant groups. (Courtesy of Saint Finbar Catholic Church.)

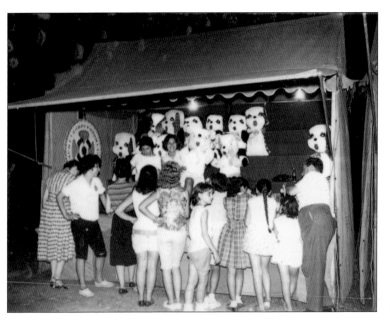

Children's Day at the Bazaar was a special event for the children of the parish. The school day was abbreviated to half a day, and rides, popcorn, and cotton candy were discounted. (Courtesy of Saint Finbar Catholic Church.)

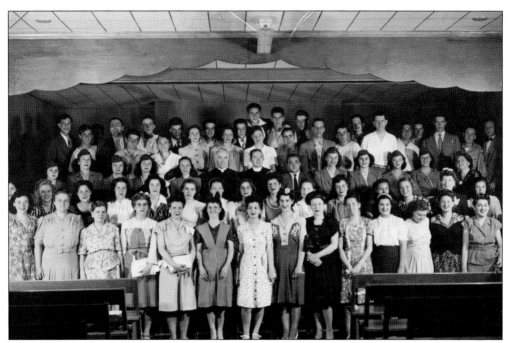

Italian parishes provided social gatherings where local parishioners entertained. The Rosary Society was a part of the Italian Ministry, a group of Italian women dedicated to the Blessed Mother through the rosary and observance of First Fridays. They conducted social events, card parties, shows, dances, fundraising, bingo, and flea markets. (Courtesy of Saint Finbar Catholic Church.)

One of the essential ways bishops responded to the pastoral challenges of immigration was to bring new religious orders into the diocese. By the early 1900s, Italian Franciscans ministered to their fellow countrymen at Park Slope, and Italian Vincentians established Saint Rocco's Church in Park Slope. (Courtesy of Saint Finbar Catholic Church.)

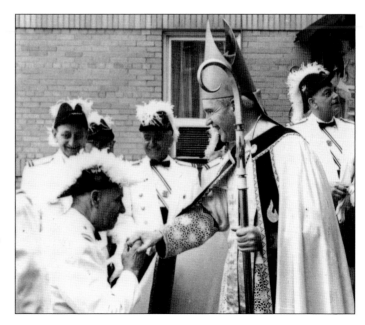

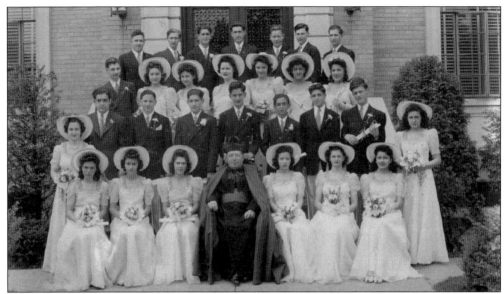

The Roman Catholic parish of St. Rosalia was founded to serve Italian Catholics. One Sunday morning in May 1942, the Bensonhurst parishioners invoked the Blessed Mother as they prayed for the safe return of American troops. The parish vowed to build a votive shrine to Regina Pacis for the victory of the US armed forces in World War II. Under the leadership of Msgr. Angelo R. Cioffi, funds were raised throughout the war years, and the cornerstone was laid in 1949. The church was dedicated as the shrine church of Regina Pacis. (Courtesy of Gabriel Carbone.)

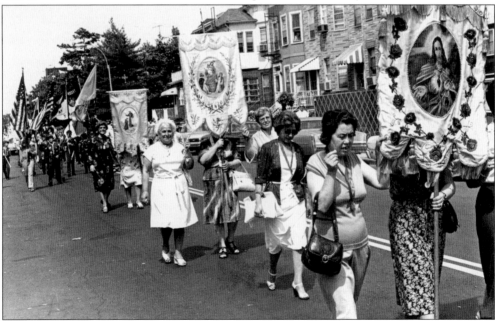

Devoted parishioners, such as Carmela Cetano (front left), lead the way to honor the Sacred Heart of Jesus through the streets of Bensonhurst. In Williamsburg, the Procession of the Giglio, a 65-foot tall tower topped by a statue carried by a team of 100 male parishioners through the streets in honor of Our Lady of Mount Carmel, still exists today. They are a source of pleasure not only for Italian American communities, but their neighbors as well. (Courtesy of Saint Finbar Catholic Church.)

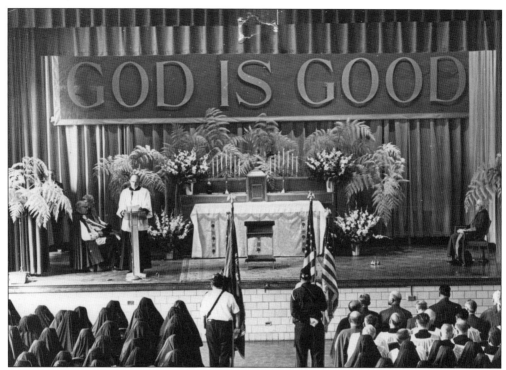

Local parishioners Rosario Biazzo, Dominick Favale, and others constructed the "God is Good" sign for the confraternity center. The faith of Italians was strengthened through sacramental articles such as crucifixes, rosaries, and scapulars. Italian homes contain pictures and statues of Jesus, Joseph, and Mary. Displays of this devotion have been a recognizable feature of Italian American life. (Courtesy of Saint Finbar Catholic Church.)

The Holy Name Society was one of the oldest of Saint Finbar's societies. The men, mostly Italian, were considered lay missionaries. They ran dances, plays, and Christmas parties and extended themselves to other parish societies and groups. (Courtesy of Saint Finbar Catholic Church.)

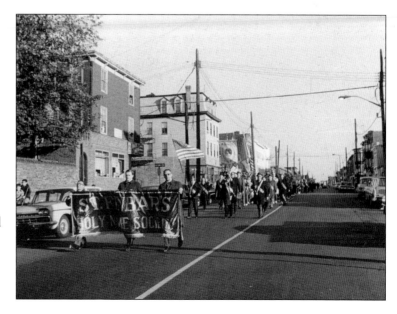

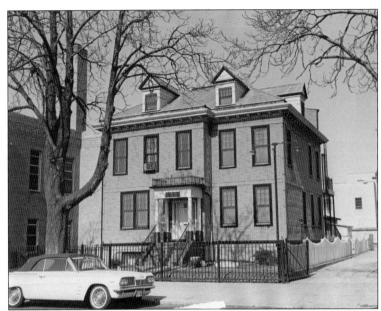

The original Saint Finbar convent housed the Pallottine Sisters until a new building was erected on Bay Nineteenth Street. Once the convent was removed, space was dedicated to creating Fr. James Donegan Plaza to honor its namesake. (Courtesy of Saint Finbar Catholic Church.)

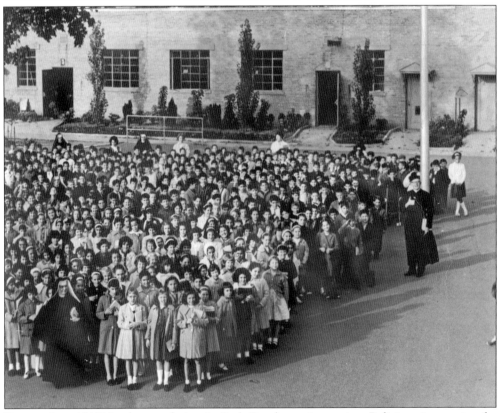

During the mid-1930s, the population in Bath Beach was increasing. Religious instruction for thousands of public schools was an immediate concern. The School of Religion, later known as the Confraternity Center/Auditorium/Gymnasium, was built. The Confraternity of Christian Doctrine (CCD) was formed soon after. (Courtesy of Saint Finbar Catholic Church.)

For Catholic immigrants, faith was a significant element in adjusting from the old world to the new. The parish became the focal point of their faith experience, their social life, and their self-understanding. As a result, the parish and the neighborhood became intertwined both for the immigrants and their children. (Courtesy of Saint Finbar Catholic Church.)

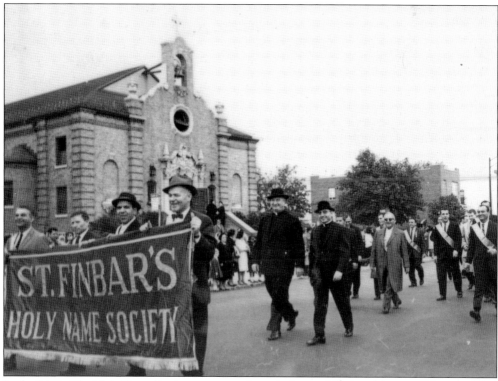

In the 1960s, The Holy Name Society processes through the neighborhood known 100 years earlier as Bensonhurst-by-the-Sea. It was once a tranquil community with fewer than 10,000 residents. In 1894, the name was shortened to Bensonhurst. Large houses were razed to build row houses and apartment buildings for immigrant families, mostly Jews and Italians leaving Manhattan's Lower East Side. (Courtesy of Saint Finbar Catholic Church.)

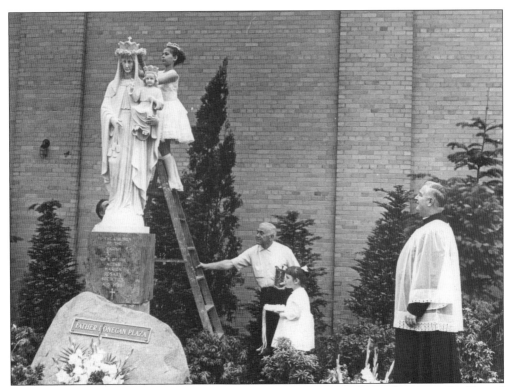

Each May, parochial schoolchildren line up in their classrooms to bring flowers to the Blessed Mother. In the schoolyards, First Communion children again wear their pristine outfits and one fortunate child leads the procession carrying a tiny woven crown of flowers perched on a small pillow. The child then climbs the ladder to crown Mary Queen of May. In the background, hundreds of children and camera-clutching parents and parishioners chant May Day hymns. The words, "Oh Mary, we crown thee with blossoms today," remain forever in their memories. (Courtesy of Saint Finbar Catholic Church.)

During World War II, Saint Finbar's nursery was created because many women with preschool children returned to the workforce. A safe, secure institution was needed that provided a well-balanced diet and loving care. Saint Finbar purchased an old post office building, which was remodeled into a well-prepared facility and municipally approved project that accommodated 150 children a day for over 20 years. (Courtesy of Saint Finbar Catholic Church.)

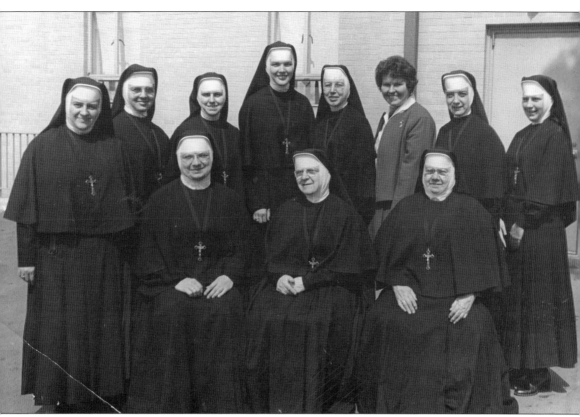

The Pallottine Missionary Sisters were the first sisters of the Congregation of the Catholic Apostolate that came to Saint Finbar in 1937. They visited every family at least once a year and acted as interpreters for the Italians, wrote letters to those serving in the armed forces, and assisted families in obtaining federal and state aid. When Saint Finbar's school opened in 1964, the sisters devoted their full time to teaching the elementary school children of the parish. By 1966, Saint Finbar's school had been established. The majority of the students were of Italian descent. The Pallottine Missionary Sisters were founded in 1838 by St. Vincent Pallotti in Rome. (Courtesy of Saint Finbar Catholic Church.)

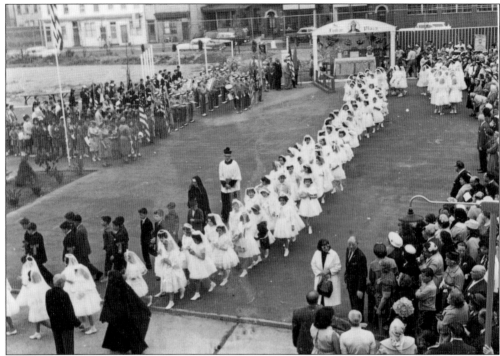

Pre-Communion drills for First Communion went on for months, with visits from the priest to provide authenticity. By the final day, the classes were well prepared. Girls dressed as brides of Christ with pristine dresses and veils, shiny new rosaries, prayer books, and small bouquets. The little boys dressed in new suits with armbands and held prayer books with rosary beads. For Catholic children, it is one of the happiest days of their lives, usually followed by a festive party and collecting money to start a bank account or add to Baptismal monies, unless, of course, the money was needed to pay for the party. (Courtesy of Saint Finbar Catholic Church.)

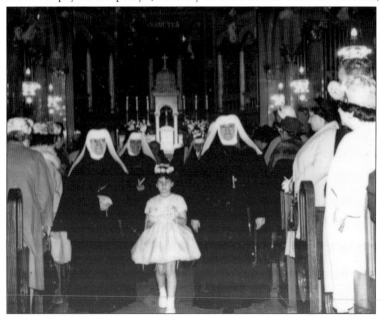

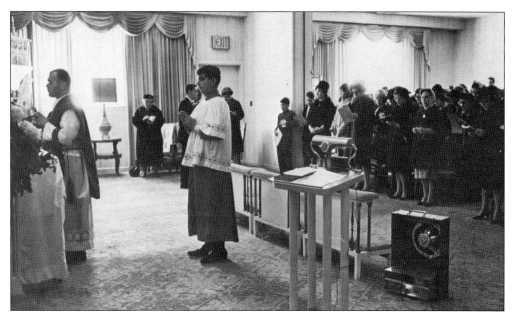

Before the completion of Saint Frances Cabrini Church in Bensonhurst in 1966, Mass was celebrated in Scarpaci Funeral Home, the Buick showroom, and John Huges Council of the Knights of Columbus. The church persevered with the fervor of Mother Cabrini ,who worked with poor and downtrodden immigrants. They responded to her concerns by developing strong, healthy communities wherever she instituted her foundations, schools, hospitals, and nurseries. The parishioners of Saint Frances Cabrini matched her zeal and determination. (Both, courtesy of Saint Frances Cabrini Parish.)

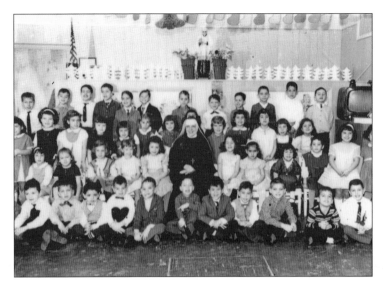

For Catholic immigrants and their children, the parish was the focal point of their faith as well as their social life. (Courtesy of Saint Finbar Catholic Church.)

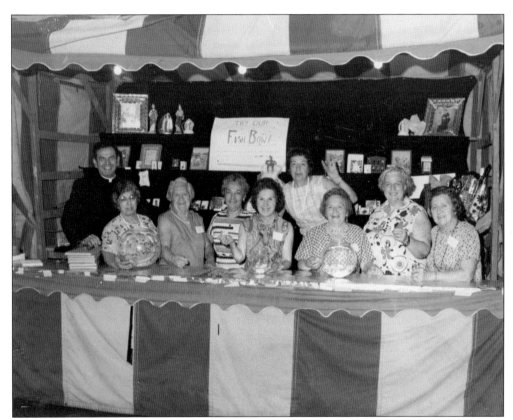

Adding to Brooklyn's exhilaration was Saint Frances Cabrini Bazaar, an exciting fundraiser event that usually ran for a week. The outdoor festival included music, rides, food, games of chance, and arcade games. Today, churches like Saint Athanasius in Bensonhurst continue the tradition, along with a street procession honoring the venerable St. Anthony. (Courtesy of Saint Frances Cabrini Parish.)

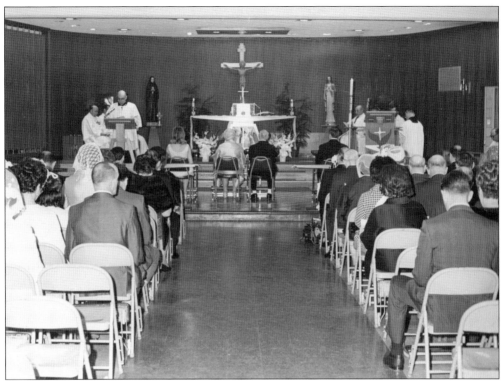

Saint Frances Cabrini Parish opened its doors on June 23, 1963, the same day Paul VI was elected pope. Pastor Father Anthony Ryder and Father Charles Boccio moved into the rectory. In the chapel of the rectory basement, the first Masses were said in the newly formed parish. (Courtesy of Saint Frances Cabrini Parish.)

Tree-lined streets on Nineteenth Avenue in Bath Beach form a backdrop for three youngsters—from left to right, Susan LaRuffa, Peter Grande, and Marianna Biazzo—on their First Communion day in 1965. The same year, an immigration act (known as the Hart–Celler Act), spurred new waves of immigration to Brooklyn in the second half of the 20th century, changing its ethnic makeup. Once immigrants had naturalized, they were able to sponsor relatives in their native lands in an ever-lengthening process called chain migration. (Author's collection.)

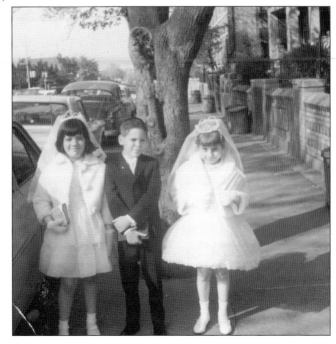

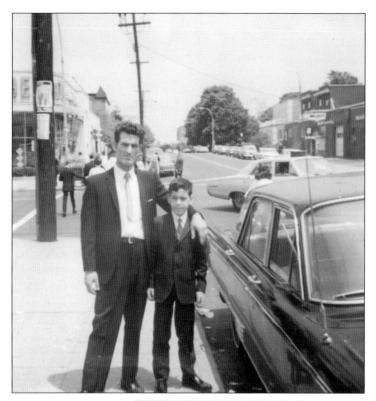

Father and son Giuseppe and Gaspare Randazzo arrive for Confirmation at Saint Frances Cabrini Church. The same year, Brooklyn-born Bishop Francis Mugavero was consecrated and installed as the fifth bishop of Brooklyn. He was the son of Sicilians. (Author's collection.)

In 1961, Joseph Esposito-Nesbitt had just made his Confirmation at St. Thomas Aquinas Church and was posing by his uncle Joe's brand new 1961 Chevrolet Impala. Across the street, another youngster is posing for her Confirmation photograph. (Courtesy of Mark Corrao.)

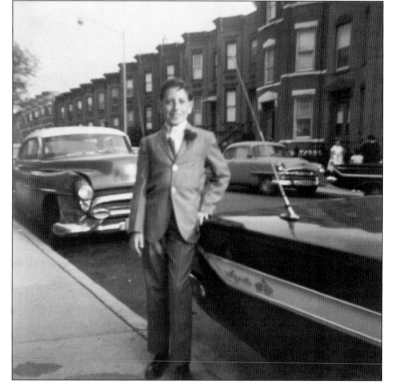

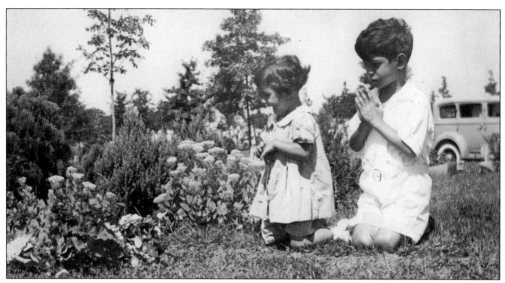

Italians have a long history of honoring and respecting their dead. Loved ones are visited at the cemetery, prayed for, and revered, unlike the practices in Italy, where lack of space mandates that cemeteries exhume bodies and place the bones in an ossuary, which is then placed into the cemetery wall. All the little boxes in the wall are adorned with photographs and vases of flowers. In America, flowers, wreaths, and shrubbery are left at the gravesite; however, bodies remain under the ground indefinitely. These children are visiting the grave of their grandfather in a Queens Catholic cemetery. (Author's collection.)

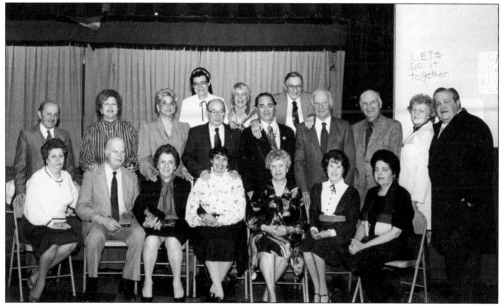

The Saint Frances Cabrini Council was an organization of elected officials among parishioners who had an impact on policymaking. With her understanding of culture and language, Sr. Concetta Amplo (third row, left), a Dominican sister, served Italian parishioners in the parishes of Saint Joseph and Saint Frances Cabrini. In later years, she taught Italian to youngsters. She was a member of the Amityville congregation for 72 years until her death in 2009 at the age of 93. (Courtesy of Saint Frances Cabrini Parish.)

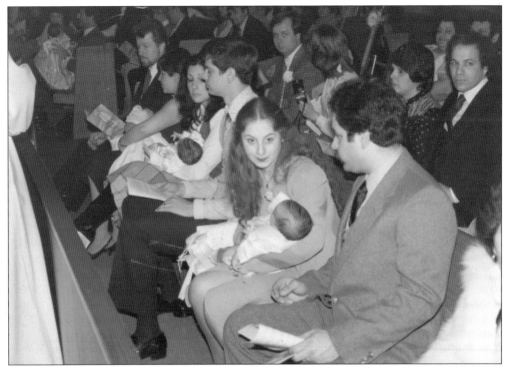

Seen here are a modern Baptism (above, 1982) and Communion (below, 1993) at Saint Frances Cabrini Church. Religious institutions have played a key role in helping Italian families preserve their culture. However, today, with most Italian Americans speaking English, there is no longer a call for Italian clergy. Churches today have priests from all over the world celebrating Masses and sacraments. (Both, author's collection.)

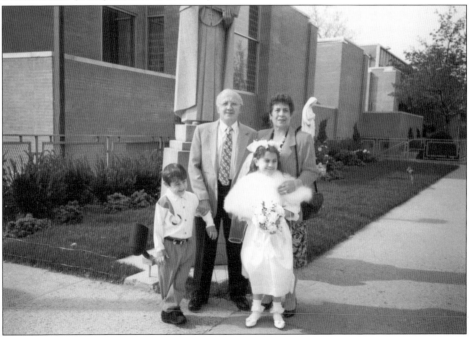

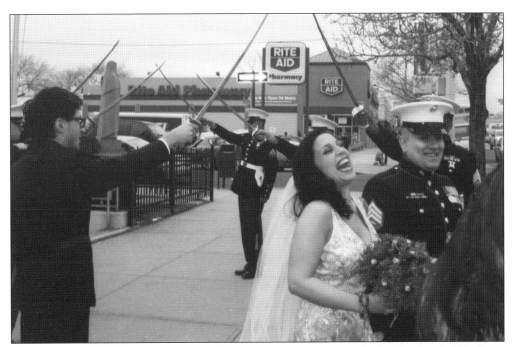

Former student Valerie Randazzo returned to her parish to marry Kenneth Restrepo by Father Sbordone. Unfortunately, like so many Catholic schools, steep declines in enrollment have forced them to close or merge with other schools. Fortunately, this church has remained open, offering Mass in English and Italian. (Author's collection.)

Anthony Favale studied five years to become a deacon after raising a family with his wife, Barbara. After completing his studies, he exclaimed, "It was a blessing to be assigned to my lifelong parish Saint Finbar by the bishop. Deacons, priests, and bishops are considered clerics, members of the clergy, in the Catholic Church." (Courtesy of Saint Finbar Catholic Church.)

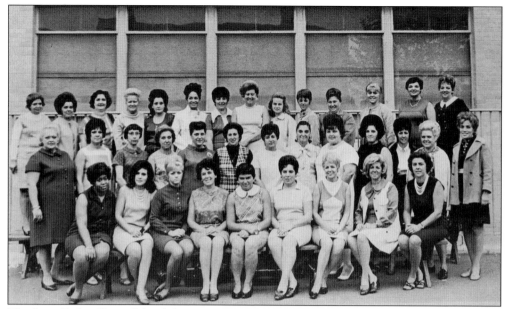

The Saint Finbar Home School Association was an organization of parents and faculty concerned with the growth and development of the children and the school. They acted as a liaison between the community, the school, faculty, and the pastor, and ran fundraisers for the extras needed in the school. Some of the events they organized included card parties, socials, dances, marathons, and bazaars. The members pictured here organized a dinner and dance at the Palm Shore Club on October 24, 1969. (Courtesy of Saint Finbar Catholic Church.)

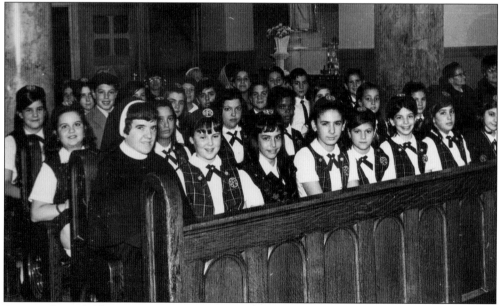

Saint Finbar's children's choir was led by sixth-grade teacher Sister Mary Christine. An organist and choirs filled the church with joy during special liturgies, wedding, and Sunday Mass, and they offered dignity to funerals. Good behavior was imperative in the church among the students, although minor infractions could be forgiven with a visit to the confessional, an Act of Contrition, or more donations to the Mission Babies fund. (Courtesy of Saint Finbar Catholic Church.)

46

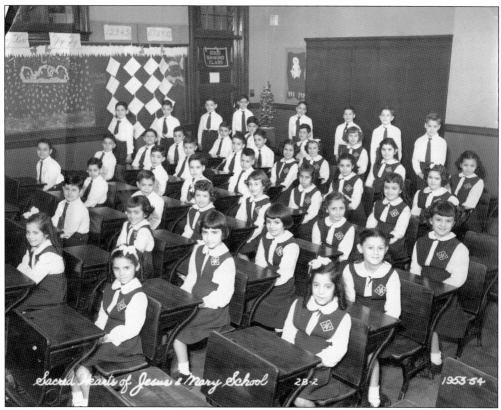

At Sacred Hearts of Jesus and Mary during the 1953–1954 school year, schoolchildren sit in neat rows. The first Italian parish to be established in Brooklyn, the Church of the Sacred Hearts of Jesus and Mary began over 125 years ago. The church was demolished to make room for the Brooklyn–Queens Expressway. (Courtesy of Veronica Grippo.)

Sisters from Bishop McDonnell Memorial High School for Girls accompany their students on a class trip. The school served girls from all over the area including Park Slope and Flatbush since 1926. By 1969, tuition was $300; the following year, it rose to $600. In 1972, the year before the school closed, tuition was $800. (Courtesy of Veronica Grippo.)

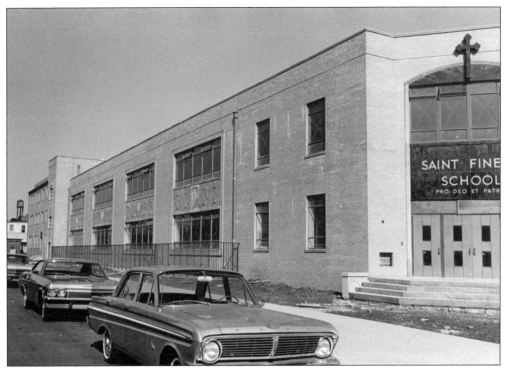

On June 6, 1965, at long last, the dream of thousands of parishioners came true. Saint Finbar had its own school: an L-shaped, two-story structure on the corner of Bath Avenue and Bay Nineteenth Street. The wings included a cafeteria, administrative offices, a library, and a teacher's lounge. Early in a child's school career, they become aware that the nuns are always watching. The sound of jingling rosary beads could snap a child into good behavior at the youngest age. (Courtesy of Saint Finbar Catholic Church.)

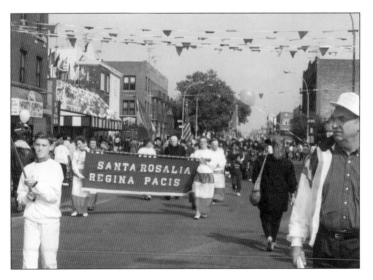

Santa Rosalia-Regina Pacis parishioners, neighborhood families, and outside visitors participate in a Columbus Day parade. The event was as respected as a holy day to patriotic Italian Americans. (Courtesy of the Federation of Italian American Organizations.)

Students and parents from Caesar Rodney Public School 164 on Fourteenth Avenue and Forty-Second Street (above) and Bishop Raymond A. Kearney High School (below) are pictured marching with celebrities. They celebrated Christopher Columbus, the Italian explorer, navigator, and colonizer. Bishop Raymond A. Kearney High School was founded in 1961 as part of the diocesan school system. (Courtesy of the Federation of Italian American Organizations.)

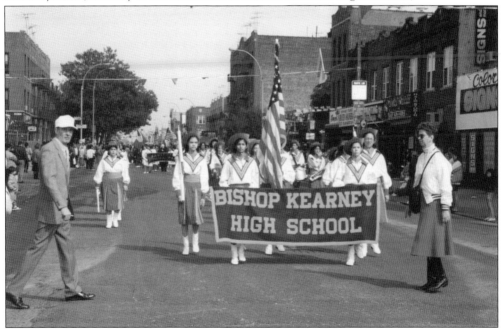

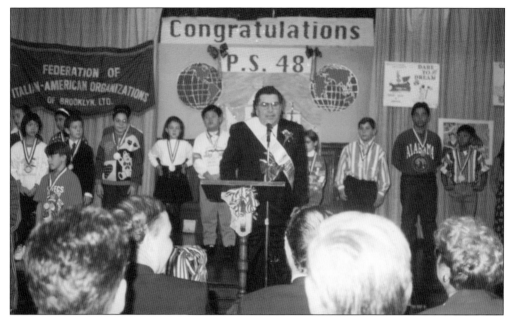

Joe Manfredi, grand marshal for the 1997 Brooklyn Columbus Day parade, addresses Bensonhurst students during a Federation of Italian Americans school program. The not-for-profit charitable community service organization, established in 1975, offers a broad range of educational, recreational, and cultural programs for youngsters and schools. Corrado "Joe" Manfredi, a businessman and the owner of Manfredi Auto Group, cherished his family and was fiercely proud of his Italian heritage. He immigrated to Brooklyn in 1952 and became a legend in the car industry. He passed away in 2015. (Courtesy of the Federation of Italian American Organizations.)

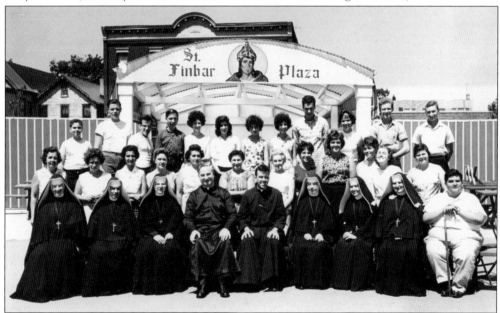

Gathered at St. Finbar Plaza are the Pallottine sisters who formed the core of the teaching staff assisted by married and single adults, college and high school students, and parish priests. They provided religious instruction to youngsters. (Courtesy of Saint Finbar Catholic Church.)

Three

WORK AND PLAY

Brooklyn, Italian, and the phrase "hard work" have been synonymous for generations. Brooklyn rose from a string of sleepy farm villages, as did southern Italians from struggling lifestyles in Italy as peasants after world wars and during Italy's decline over the decades. Brooklyn taught all kinds of people to become Americans. By the 1950s, the grandchildren of immigrants no longer spoke the Italian they heard on the streets, in church, or in the home. The yearning to assimilate had been reinforced by a significant wartime surge of patriotism and a fear of what was un-American. Italian Americans of the first and second generations experienced discrimination and violence for being different. They became objects of prejudice, which usually feeds on fear of the unknown, or different. Early immigrants looked upon education with suspicion; it was difficult to change attitudes. During the Depression years, from 1929 to 1940, legal aliens found it even more difficult to find jobs because of Americans who concluded that the scarcity of employment was caused by "foreigners" who were taking their jobs. The whole country struggled. Youngsters made their sidewalks and stoops their playgrounds. Brooklyn Italian Leonard Riggio, founder and chairman of Barnes & Noble, served as grand marshal of the 73rd Columbus Day parade in 2017. Riggio created the theme for the parade: A Celebration of Italian-American Authors. Among the authors who marched in the parade were Tony Danza and Dr. Gina Barreca. Tony Danza, born in Brooklyn, a former pugilist, actor, director, and producer, is the son of Matty, a sanitation worker, and Anne Ladanza. Italian family recipes and stories fill his first book. His second book is an account of a year he spent teaching 10th-grade English. Dr. Gina Barreca is also a Brooklyn native. Her books discuss gender, power, politics, and humor. Her weekly columns in the *Hartford Courant* are distributed internationally by the Tribune Company, and her work has appeared in several major publications. Most Italian Americans are proud to have grown up in Brooklyn. The borough taught toughness, and although many people moved away, others stayed in Brooklyn their whole lives. The competitive advantages that Brooklyn instilled were the experience and knowledge to deal with any difficulty or danger. It also instilled a passion for food, life, and love, and a sensitivity to different cultures with shared experiences. By choosing Brooklyn as their home, even temporarily, Italians chose well. Today, schools teach diversity, but in Brooklyn, one lived it.

Nick Piazza stands beneath the midwife business of his aunt Pauline Pullo. His uncle Alfonso Piazza sits on the stoop in Greenpoint with crossed hands around 1940. The "Midwife" sign is written in English and Italian (*levatrice*). Over the past 100 years, Italian Americans have moved into jobs and professions of every kind. Where previously they were considered unskilled laborers, they are counted as a major presence in almost every field today. (Courtesy of Tom Gulino.)

Broadway actress of "Gypsy" fame Faith Dane stops off at Montano's luncheonette to pose with Joe Montano while entertaining the troops in Brooklyn. Music is often considered Italy's greatest gift to this country. Dating to the 19th century, Italians, music, and Brooklyn have gone together. Giovanni Domenico Mariani, born in 1805 in Milan and living in Brooklyn at 55 Cumberland Street, worked as a drum major for the Union army. Later, he was a member of Mapleson's Italian Opera Company at the New York Academy of Music until 1885. (Courtesy of Jerry Montana.)

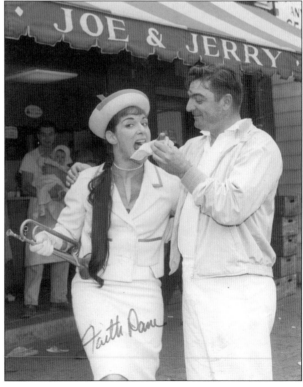

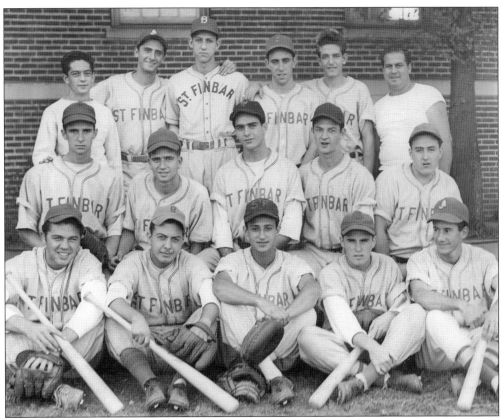

Like other minority groups, Italian Americans attracted attention through their abilities in sports. At first, they felt the need to conceal their Italian names, but in time, the situation changed. In this 1948 baseball team senior portrait, in the third row, second from left, is Ralph Schirripa, father of actor Steve Schirripa. Third from left is Raymond Pecoraro, who was also a member of Lafayette High School's baseball team that won the first city championship. Pecoraro went on to St. John's University on a four-year baseball scholarship and earned his law degree. After graduation, he enlisted in the Marines. Upon his return, he began a career as an attorney, starting a practice in Bensonhurst, where he continues to practice. (Courtesy of Saint Finbar Catholic Church.)

Churches were committed to offering direction and leadership for the parish youth. Laws required all children to attend school and learn English. These were opportunities to be introduced to scouting, sports, cultural outings, and religious instruction. (Courtesy of Saint Finbar Catholic Church.)

Italian funeral homes have been a fixture in Brooklyn, serving and supporting the Italian Catholic population for almost 100 years. It has been a long struggle for Italian immigrants to gain a respected place in American society, but gain they have. Today, their descendants are represented in every profession: medicine, law, government, education, and technology. They serve as judges, sports heroes, laborers, artists, and merchants, and in every profession. The depth and extent of the prejudices against Italians have been forgotten by new generations. Today, these funeral homes are adapting to changes in the community. (Courtesy of Saint Finbar Catholic Church.)

In the 1940s, Gabriel Carbone entered Brooklyn College as a chemistry major. It was a culture shock finding Italians in the minority at the college. "I took stock of myself . . . and decided it was time to become appreciative of my heritage," said Carbone. The school was 90 percent Jewish at the time, but Carbone recognized cultural commonalities and made many friends. He joined the Beta Eta chapter of Alpha Phi Delta fraternity, a group that shared similar ancestry. Carbone's faculty advisor was Eugene Scalia, father of Antonin Scalia, who was a justice of the US Supreme Court from 1986 to 2016. In 1950, Carbone began work at the Department of Health and earned the title of principal chemist. Later, he became the director of the Environmental Chemistry Laboratory, and in 2014, he was awarded the Brooklyn College Lifetime Achievement Award. (Courtesy of Gabriel Carbone.)

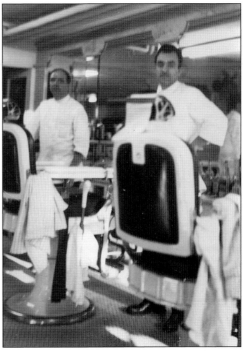

Joseph LaRotonda, a barber from Naples, initially lived on Arthur Avenue in the Bronx but later purchased the family a home on 19th Avenue. He found work as a barber at the Brooklyn Jewish Hospital in Crown Heights, one of the best hospital complexes in Brooklyn. In the neighborhoods, the iconic swirling red pole announced a barbershop; however, beauty parlors only began to emerge as wages improved and surplus income began to accumulate. Before that, female hairdressing was not considered a necessity, but a man always needed to have his hair cut. (Courtesy of Marie Fioriglio.)

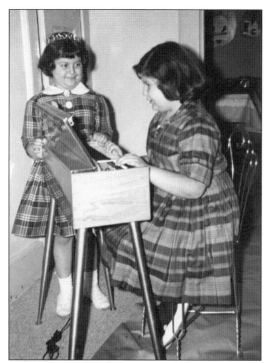

Joanna and Lois Lembo practice on their electric organ in their home in Bensonhurst. In 1961, little girls played with Betsy Wetsy and Shirley Temple dolls, and sewing machines. Little boys played with toy cap guns, model planes, and spy detector games. Men were seen as the sole breadwinner of the family, and were not expected to perform any housework. For many Italian women, it would be decades before they saw workplace and home equality. (Courtesy of Joanne Mantovani.)

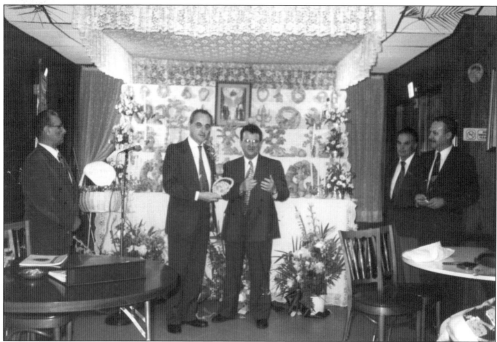

Among the pleasures of life in the Italian American communities were the feasts celebrated in honor of favorite saints, local bazaars, and processions. Italians' celebration of Saint Joseph, the patron saint of workers, is most significant. On this day, Italians, especially Sicilians, build an altar with bread to honor the saint. They also eat a meal of *pasta con sarde* (macaroni with sardines). (Courtesy of the Federation of Italian American Organizations.)

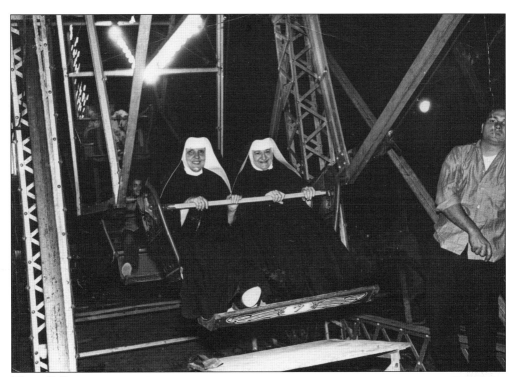

These Pallottine sisters enjoy a ride on the Ferris wheel. Despite what children believed, nuns did know how to live. (Courtesy of Saint Finbar Catholic Church.)

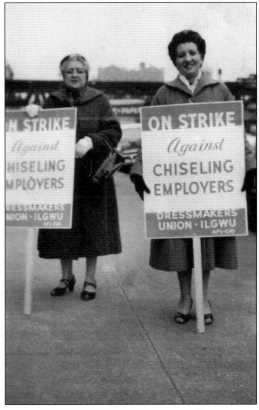

Nancy Iannello was a dressmaker in a factory in Brooklyn. In 1958, there was a strike by the International Ladies' Garment Workers' Union (ILGWU). Iannello was given a day and time to appear on the picket line. She was also given this sign. By the beginning of the 20th century, Italian workers organized themselves and went on strike for shorter hours, better pay, and improved working conditions. These strikes ushered in new generations of Italian American labor leaders and union members. Decades earlier, most immigrant laborers were imported under the padrone system, which did not favor labor organization. (Courtesy of Geraldine Graham.)

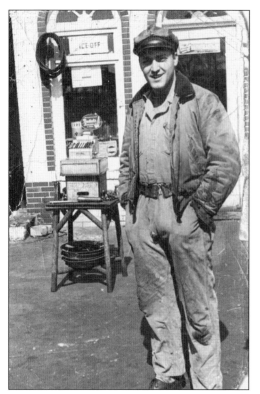

Aldo Mancusi credits his Brooklyn high school teachers for his education in automobile mechanics. Mancusi stands in front of one of his first jobs in a gas station, where he honed his skills. As a young man, his appreciation for his father's collection of Enrico Caruso records grew exponentially, leading him on a path toward collecting and appreciating the great tenor and opera. (Courtesy of Commandatore Aldo Mancusi.)

Outside of a family-owned grocery store on Eighteenth Avenue, a little girl sits on the icebox advertising Pepsi-Cola and Mission Orange. In the 1930s, small, independent grocery stores were abundant. (Courtesy of Raffaella De Santo.)

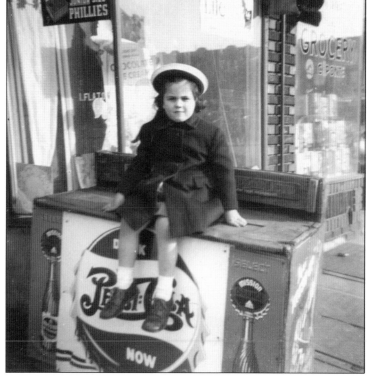

Members of the Kiwanis Club of Gravesend, seen here around 1956, are entertained by a barbershop quartet. Second from the right is sanitation department foreman Louis Falco, who lived to be 102 years old and collected a pension for 52 years. (Courtesy of Joanne Mantovani.)

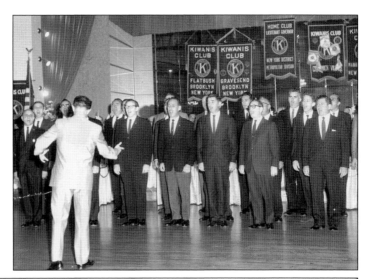

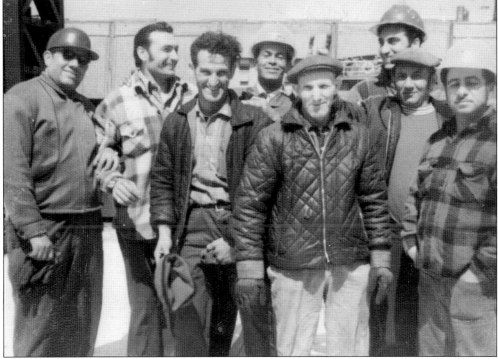

Longshoremen await their assignment at the docks, hoping to get work on an arriving ship, around the 1960s. Despite being some of the most dangerous jobs in the country, men had to beg to get work. They ran the risk of losing limbs, getting crushed, and being harassed by corrupt union officials and gangsters. Despite Italians immigrants' involvement in such industries as road construction, coal mining, garment work, and much more, few had achieved national prominence as labor leaders. There were also major differences, especially language, between the Italians and the groups that ran the unions. The longshoreman's job changed when goods were no longer shipped loosely but were put into containers and stacked and transferred between ships, trucks, and trains. Giuseppe Randazzo, third from left, was crushed by a forklift vehicle in the 1970s. He survived but had to retire from the job. (Author's collection.)

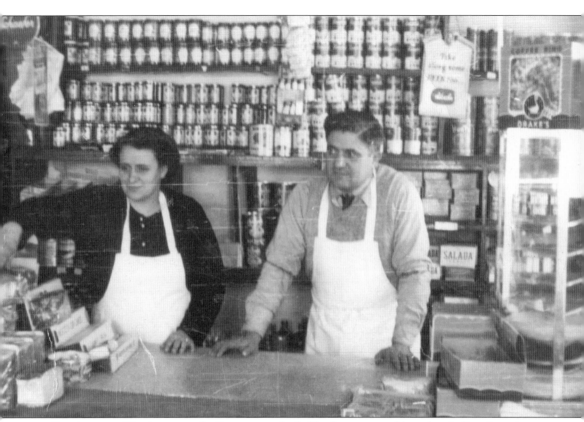

Owning a small business was the first step up the ladder for many working-class Italian Americans. When refrigeration replaced the need for icemen, Nicolo Squicciarini and wife, Sophia, rented a grocery store on Seventh Avenue and Eighteenth Street. Because of his inability to read and write English, their daughter Angela tended to the books. In 1946, their building was demolished for construction of the Brooklyn Queens Expressway. Because they were renters, no compensation was given, ruining the family financially. Nicolo later took jobs as a building custodian. In 1977, Angela became the first woman vice president at WNET New York. (Courtesy of the Squicciarini family.)

Gennaro "Jerry" Pero, younger son of Antonio "Totonno" Pero, took over Totonno's Pizzeria in his early 20s. Previously, he worked in the Brooklyn Navy Yard until World War II ended on August 15, 1945, which happened to be his birthday. He called in to work that day to say that he would not be coming in because he wanted to celebrate his birthday and the end of the war. He was told not to return. He then began making pizzas for his father, Totonno, and continued until the 1990s. His nephew Joel Ciminieri and great-nephew Lawrence Ciminieri took over until the turn of the 21st century, when the present pie maker, Michael Gammone, began. (Courtesy of Antoinette Balzano.)

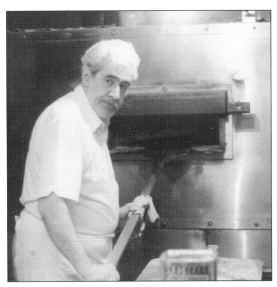

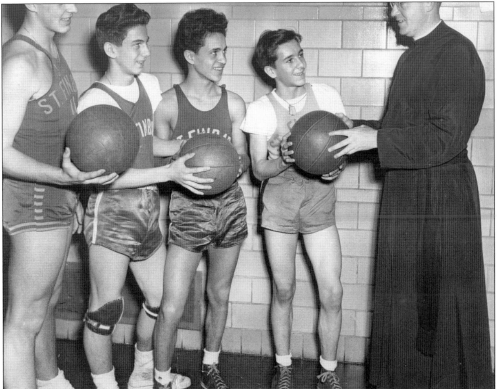

During the glory years of the Saint Finbar sports programs, about 1940 to 1980, boys and girls learned sportsmanship. In the 1940s, with war raging, American culture was affected. All men between the ages of 18 and 26 years of age were expected to serve in the Army. This also changed sports. Rubber went to the war efforts, so sports balls were made differently. There was also a shortage of wood, making bowling pins and baseball bats hard to find. Some very tall basketball players were not affected, because their height made them ineligible for service. (Courtesy of Saint Finbar Catholic Church.)

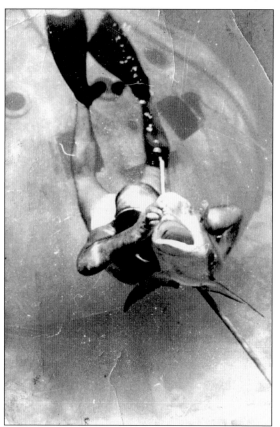

Giovanni Venuto is seen here working as part of French deep sea explorer Jacques Cousteau's Calypso Red Sea Expedition (1951–1952). In the background is Cousteau's underwater lab. Venuto's life in Brooklyn revolved around being a longshoreman in Red Hook and then the promoter and manager of his sons' band, the Caleps. The affable man and his family were well known in their Brooklyn neighborhood and organized the first block party on Eighty-Fourth Street. (Courtesy of Liana Amodeo.)

The Verrazano-Narrows Bridge was Robert Moses's last stand. Named after Giovanni da Verrazzano, with two Zs, the bridge had been a topic of discussion since the late 1800s. Although Moses typically preferred naming structures for places instead of people and originally wanted it to be called the Narrows Bridge, Italian Americans lobbied to name it after the first European explorer to lay eyes on New York Harbor: Giovanni da Verrazzano. (Courtesy of Saint Finbar Catholic Church.)

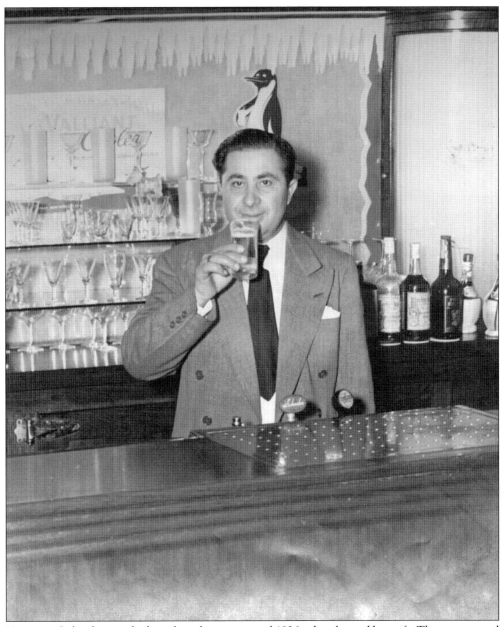

Vincenzo Colandrea worked as a longshoreman until 1936, when he and his wife, Theresa, opened a pizzeria. As business grew, in 1938, the couple expanded their facility to three tables and hired two employees. In the 1930s, choices for dining out were limited to automats, cafeterias, and coffee shops. With high unemployment and low wages, eating out was not an option for most people, but good, reasonably priced food and a friendly atmosphere helped the Colandreas build their business. (Courtesy of the Colandrea family, New Corner Restaurant.)

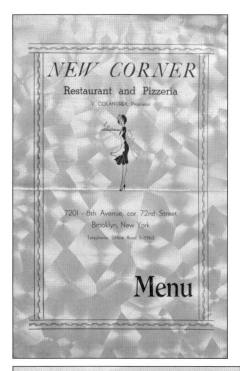

NEW CORNER
Restaurant and Pizzeria

V. COLANDREA, Proprietor

7201 - 8th Avenue, cor 72nd Street
Brooklyn, New York
Telephone: SHore Road 5-8963

Menu

The front cover of this menu boasts "V. Colandrea, Proprietor." It is from around 1939, during an era when the hourly wage was 25¢ and Sea Biscuit beat War Admiral at Pimlico. People were celebrating, and for a while, it took their minds off the Depression and impending war. The average cost of a new house was $3,900, with rent averaging $27 a month, and the cost of gas was 10¢ a gallon. (Both, courtesy of the Colandrea family, New Corner Restaurant.)

APPETIZERS

Italian Antipasto	.50	Anchovies in Olive Oil	
Special Antipasto	1.00	Italian Ham	
Spanish Pimentos and Anchovies	.75	Shrimp Cocktail	
Celery and Olives	.60	Provolone Cheese	
	Italian Salami		.70

SOUPS

Minestrone	.40	Consomme with Spinach	
Consomme	.25	Consomme Escarole	
Consomme Noodles	.40	Vegetable	
Consomme Romana (stracciata)	.40	A la Pavese Soup	

SPAGHETTI

Manicotti (Home Made)	.75	Spaghetti with Meat Balls and	
Ravioli (Home Made)	.70	Meat Sauce	
Lasagna (Home Made)	.75	Spaghetti with Veal Cutlet	
Spaghetti, Tomato Sauce	.50	Spaghetti with Sausages	
Spaghetti, Butter Sauce	.55	Spaghetti with Veal and Peppers	
Spaghetti, Marinara Sauce	.55	Spaghetti with Veal Cutlet Parmigiana	
Spaghetti, Meat Sauce	.55	Macaroni, Sicily Style	
Spaghetti, Anchovy Sauce	.75	Ravioli with Meat Balls	
Spaghetti with Clams	.75	Ravioli with Veal Cutlet	
Spaghetti with Mushrooms	.75	Ravioli with Veal Cutlet Parmigiana	
Spaghetti a la Caruso	.80	Ravioli with Sausages	
Spaghetti with Chicken Liver	.75	Noodles, Bolognese	
Spaghetti with Meat Balls	.70	Eggplant, Parmigiana	
		Extra Butter 5c	

ENTREES

VEAL SCALLOPINE NEW CORNER 1.25		Veal a la Cacciatora	
Veal Scaloppine French Style	1.00	Veal with Mushrooms	
Veal Scaloppine Pizzaiola	1.00	Veal and Peppers	
Veal Scaloppine with Mushrooms	1.10	Veal Rollatine, Broiled	
Veal Scaloppine Marsala, Sherry	1.10	Veal Rollatine a la Marsala	
Veal Scaloppine Piccante	1.00	Braciola Naples Style	
Veal Scaloppine Roman Style	1.00	Braciola with Spaghetti	
Veal Cutlet Milanese	1.00	Meat Balls with Potatoes	
Veal Cutlet Parmigiana	1.10	Meat Balls with Mushrooms	

ROAST AND GRILL

Ham and Eggs	.75	Chicken (half) Broiled	
Steak	2.50	Chicken (half) a la Cacciatora	
Special Steak	5.50	Filet Mignon Broiled	
Steak Pizzaiuola	3.00	Italian Sausages Broiled	
Veal Chops, any Style	1.50	Roast Beef	
Lamb Chops, any Style	1.50	Roast Veal	
Pork Chops, any Style	1.50	Kidneys with Onions	
		Kidneys with Mushrooms	1.00

FISH

Clams Poslica (Soup of Clams)	.85	Shrimps, Spaghetti	
Clams on Half Shell	.65	Filet de Sole	
Clams Casino	1.00	Filet de Sole, Spaghetti	
Clams Oven	.75	Scungilli	
Shrimps, Fried	1.00	Scungilli, Salad	
Shrimps, Marinara	1.10	Lobster, any Style	

OMELETTES

Plain	.60	Spanish	.95
Cheese	.70	Peppers	.85
Ham	.85	Mozzarella in Carrozza	1.00
Mushrooms	.85	Spiedini alla Romana	1.10
Onions	.70		

VEGETABLES

Spinach Saute	.60	Broccoli, Hollandaise Sauce	1.25
Escarole Saute	.60	String Beans, Marinara	.80
Escarole a la Monachina	.75	String Beans, Butter Sauce	.75
Broccoli to Order	.70	Green Peppers, Marinara	.75

PIZZE

Tomatoes and Cheese	1.00 and up	With Onions and Cheese	1.25 and up
Marinara	1.00 and up	With Clams	1.50 and up
Anchovies	1.00 and up	Vincent Special	1.50 and up
With Mushrooms	1.50 and up	Calzone Imbottito	1.50 and up
Spanish Onions and Peppers	1.50 and up		

SANDWICHES

Sausages	.50	Combination	.75
Peppers and Eggs	.50	Roast Beef	.80
Ham and Eggs	.55	Roast Veal	.75
American Cheese	.50	Veal Cutlet	.60
Swiss Cheese	.50	Provolone Cheese	.50
Meat Balls	.50	Veal and Peppers	.50
Lettuce and Tomatoes	.40	Chicken	.75
Italian Salami	.70	Steak	1.50
		Ham	.60

SALADS

NEW CORNER GARDEN SALAD	.75	Combination	.65
Plain	.50	Shrimp	1.00
Lettuce and Tomatoes	.55	Egg	.65
		Chicken	.85

DESSERTS

Zabaglione	.60	Italian Spumoni	.30
Italian Cheese Cake	.30	Bisquit Tortoni	.25

IMPORTED CHEESE

Gorgonzola Cheese	.80	Provolone Cheese	.60
Bel Paese Cheese	.80	Italian Fresh Cheese (Mozzarella)	.80

COFFEE — TEA

Coffee	.10	Milk	.10
Italian Demitasse	.10	Tea	.10

Joseph Colandrea is reviewing blueprints for the expansion of New Corner Restaurant in 1971 in his office. Partnering with his father, Vincenzo, he used the same inflexible formula for success: hard work. Previous to their partnership, Joseph, a graduate of Steven Institute of Technology, had been an engineer working for the Newport News Shipbuilding and Dry Dock Company. The fruit of their labor lives on today at 7201 Eighth Avenue: New Corner Restaurant. Currently, Joseph's two sons, Vincent and Steven Colandrea, are the third-generation managers who adhere to the strict formula inherited from their father and grandfather. (Courtesy of the Colandrea family, New Corner Restaurant.)

In the 1900s, Italians brought many things with them to America, among them the game of bocce. In the early days, this game was purely for old Italian men. In reality, throwing balls toward a target is the oldest game known to mankind. Even Egyptians played a form of bocce with polished rocks. Another favorite Brooklyn hobby became pigeon breeding. Brought by Irish and Italian immigrants, breeders could be found on every block in every borough. Most New Yorkers see them as annoying scavengers, but during World War II, carrier pigeons saved lives delivering vital messages through what was known as "pigeon post." (Courtesy of Joanne Mantovani.)

A trip to Story Book Town in Lake George, New York, was a tremendous treat for a Brooklyn child in 1958. Joanne Lembo poses at left with a friendly clown. Below, in 1946, four buddies clown around on a park bench showing off glamour gams like the movie stars of the day. (Both, courtesy of Joanne Mantovani.)

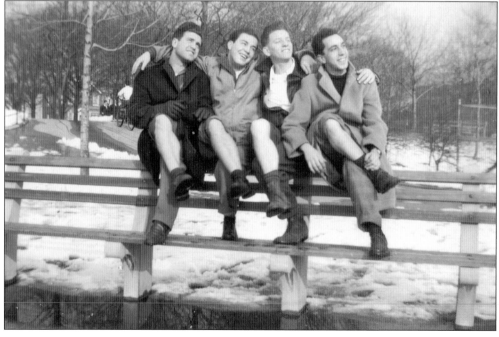

Jack Spatola arrived from Sicily at the age of 14. He taught bilingual and special needs children in the challenging neighborhoods of Bushwick and became the principal of Public School 172 in Sunset Park. David Dinkins (center) served as mayor of New York from 1990 to 1993. (Courtesy of the Federation of Italian American Organizations.)

In this 1960s photograph, Gale Mileo is braced for her boat ride at Nellie Bly amusement park, named after the adventurous reporter. Gale attended Flatbush public schools and taught the children of Bensonhurst for over 30 years. (Courtesy of Gale Mileo D'Onofrio.)

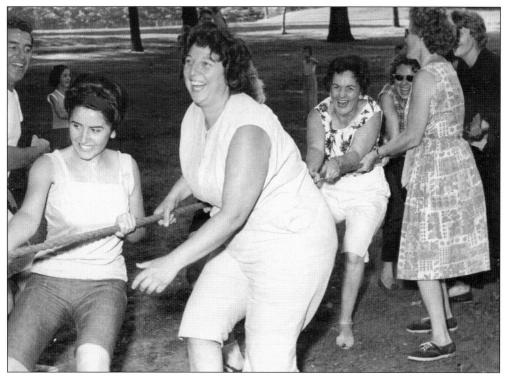

Marie Lembo is giving it her all at a game of tug-of-war at the Italian Barber Shop Quartet Family Picnic. The picnic took place on the grounds of Poly Prep. In 1916, a 20-acre parcel of land, formerly the Dyker Meadow Golf Course, was offered to the trustees. On July 1 of that year, the Polytechnic Preparatory Country Day School was incorporated. The school was initially located at 99 Livingston Street in Brooklyn Heights, and in 1854 was known as the Brooklyn Collegiate and Polytechnic Institute. It was the first school for boys in the city of Brooklyn. It soon became known as "the Poly." (Courtesy of Joanne Mantovani.)

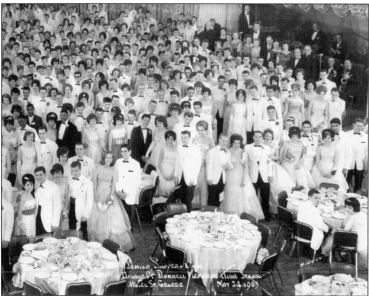

In 1963, the Bishop McDonnell Memorial High School Senior Supper Prom was held at the elegant Hotel Saint George, the nation's largest hotel. In its heyday, its guests included F. Scott Fitzgerald and Truman Capote. Capote swam regularly in the hotel's Art Deco saltwater pool. On this prom night, teenagers swayed to the music of Bobby Darin. (Courtesy of Veronica Grippo.)

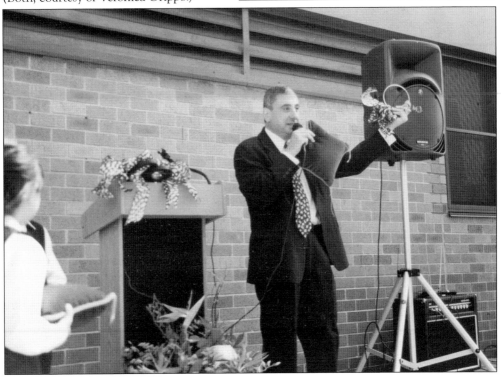

Vincent Grippo gives a military
salute at right outside his home on
First Place in 1950. A man of great
vision, his career spanned decades. A
champion for children, Grippo served
as a teacher, dean, and superintendent
for almost four decades in District 20
schools. Brooklyn's Public School 69
is named for the dedicated educator.
Below, Grippo is opening a new school.
(Both, courtesy of Veronica Grippo.)

Giovanni and Maria Venuto are pictured with Sen. Alfonse D'Amato (right) at the Cotillion Terrace in 1983. Born in Brooklyn in 1937, D'Amato served as a US senator from New York from 1981 to 1999. (Courtesy of Liana Amodeo.)

When a customer showed up on a horse at the Bath Avenue music store, Castellano cousin Tony Varano saw it as a photo opportunity. Bath Music was more than guitar and sheet music—it was a place where the community was welcomed, love grew, and grief divided, thanks to the original proprietors, Marion and Phillip Castellano. A street sign at the corner of Bath Avenue and Bay Twenty-Eighth Street honors the late Marion Castellano, and Castellano's House of Music continues to flourish in Staten Island. (Courtesy of the Castellano family.)

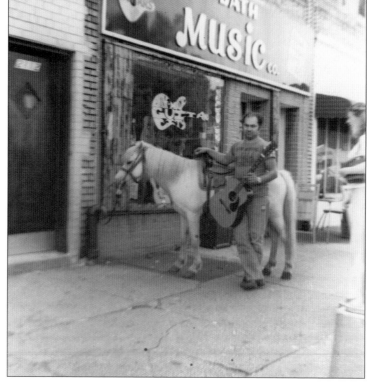

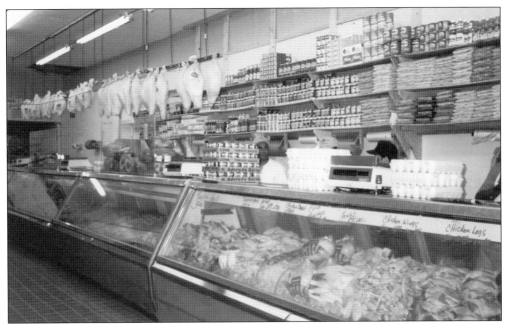

When tailor Giuseppe Randazzo and his wife, Maria, came to America in 1967 from Sicily with their two young sons, the future was unclear. Soon, the boys began working with their uncle after school in his butcher shop. In 1980, it became clear that father and sons would start their own business. Parkway Meats was established and remains in business today. The full-service butcher shop, located at 257 Schenectady Avenue in Crown Heights, was named for the main intersection on the corner, Eastern Parkway. Giuseppe worked with his sons for over 25 years. Pictured above is Joseph, son of Giuseppe, and below is Salvatore, son of Giuseppe and brother of Joseph. (Both, courtesy of Joseph Randazzo.)

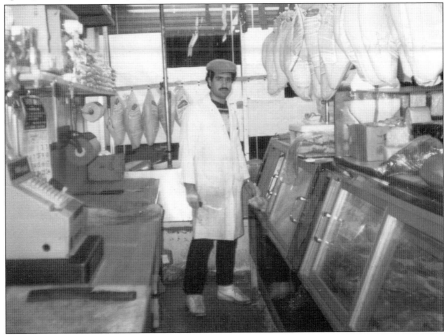

It has been said that Aldo Mancusi's first language was Italian, but his second was music. His father, an Enrico Caruso lover, was blessed with a family of musicians that congregated at his home on Union Street. Public school was a struggle for Aldo, who had German teachers who were less than sympathetic to the children of Italian immigrants; however, he did love the school lunches. Eventually, his intelligence surfaced, and his successes in school became evident. In high school, he had a talent for mechanics. It was his job to fix the teachers' cars. His passion for music grew through the years, as did his collection of Caruso records and artifacts. Today, he is the founder and curator of the Enrico Caruso Museum of America, located in Brooklyn. Enjoying a tour of the museum are, from left to right, consul general Natalia Quintavalle, Aldo and wife Lisa Mancusi, Eric Murray (Enrico Caruso's grandson), borough president Marty Markowitz, and deputy consul Luci Pasqualini. Aldo played "Questa o Quella" from Verdi's *Rigoletto* and "Core 'n Grato" from a large Victor 6 phonograph with a golden horn for his distinguished guests. (Courtesy of Commandatore Aldo Mancusi.)

Accepting the National Italian American Foundation (NIAF) Community Leadership Award in 2016 is Brooklyn-born Dr. Aileen Riotto Sirey, an accomplished psychotherapist. At left is actor Joe Piscopo, and at right is NIAF president John Viola. The 1970s were blossoming years for pride among Italian Americans. In 1980, Sirey launched the National Organization of Italian American Women (NOIAW) from her home. Among the original group of women were Geraldine Ferraro, Roseanne Colletti, and Matilda Raffa Cuomo. The organization continues to represent Italian American women of varied professional and business backgrounds. The motivation behind the organization's creation was a desire to bust stereotypes of Italian American women. NOIAW promotes and supports the advancement of women of Italian ancestry. Progress is accomplished through cultural programs and networking opportunities and encouraging young women through scholarships, mentoring, and international cultural exchange programs. Sirey has demonstrated extraordinary achievements. She is a recipient of the Ellis Island Medal of Honor, among other awards. She is also Cavalieri and Commandatore in the Order of Merit of the Republic of Italy. (Courtesy of Aileen Riotto Sirey.)

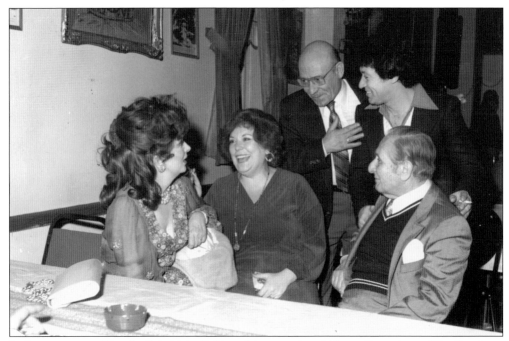

Italian superstar Gina Lollobrigida (left) and international Neapolitan singer Rita Berti are guests of Giovanni Venuto (standing left) at a 1979 Halloween party at his local social club. In the 1970s, Lollobrigida shifted her talents from acting to becoming a successful photojournalist and documentary filmmaker. (Courtesy of Liana Amodeo.)

Annette Pensabene Marten poses on the Marine Park playground donning a kerchief on her head, bobby socks, and penny loafers, fashion staples of 1955. Today, an accomplished artist, Marten's work has been presented to 41st president George H. Bush and is in the Texas A&M library. (Courtesy of Annette Pensabene Marten.)

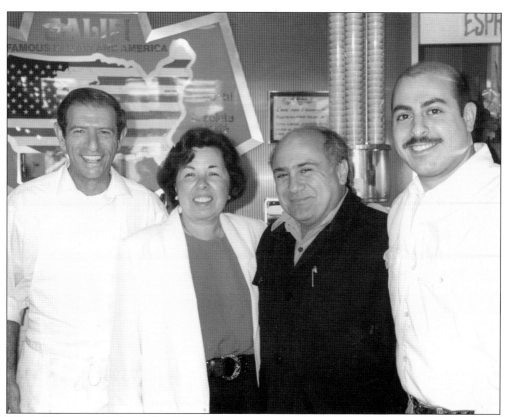

While filming in 1995 in Dyker Heights, actor Danny DeVito stopped for an espresso and pastry at the Galifi Bakery, which Connie and Vito Galifi have owned and operated since 1966. After his first experience, he dropped by every day. He even had pastries sent to his wife, Rhea Perlman, in California and bought cookies for his family in New Jersey. Other distinguished customers included news anchor Rosanna Scotto, a former Dyker Heights resident. "We made a beautiful cake for her daughter's christening," said Connie with pride. "She was very, very pleased with it." Taking great pride in all their creations, the Galifis display the marzipan ship at right honoring the Genoan explorer Christopher Columbus. (Both, courtesy of Connie and Vito Galifi.)

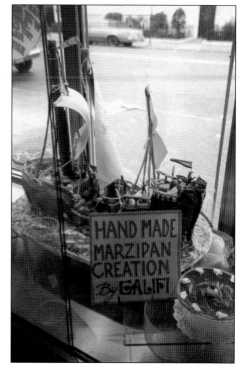

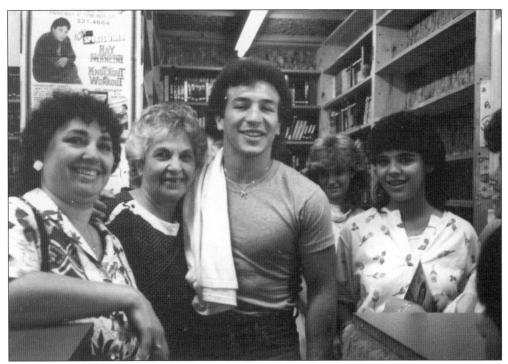

Italians have made a positive impact on American boxing. Raymond Michael Mancini, best known as Ray "Boom Boom" Mancini, is a former professional boxer who competed from 1979 to 1992 and has since worked as an actor. He held the WBA lightweight title from 1982 to 1984. Making an appearance at Parkway Video, he is surrounded by the owner's family. From left to right are Rose McKuen, Assunta Prestininzi, Mancini, Sue Ann DiPrima, and Nancy DiPrima. (Courtesy of Rose Prestininzi.)

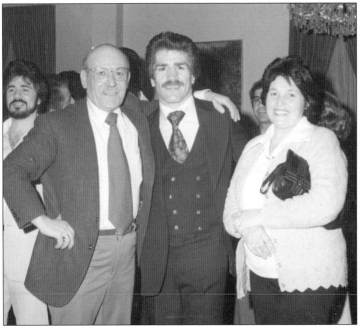

Giovanni and Maria Venuto welcomed professional boxer Vito Antuofermo to their circle of friends. After retiring from boxing, Antuofermo pursued an acting career. He appeared in films such as *La bomba*, *New York Cop*, *The Godfather*, and *Goodfellas*. He is a former undisputed world middleweight champion. He fought out of Brooklyn. (Courtesy of Liana Amodeo.)

L'Idea magazine was born in 1974 as a periodical for the Circolo Culturale di Mola, a Brooklyn association of young Molese citizens in the United States. Through the years, it became more significant to the Italian American community. In 1990, Tiziano Dossena assumed the role of editorial director. *L'Idea* had its administrative offices in Brooklyn for 39 years, until it stopped its paper version. The magazine funded and sponsored many cultural and social activities for the Italian community, including the yearly Miss Puglia USA and Miss L'Idea competitions. Winners received scholarships. Pictured above from left to right are Italian consul for New York/Connecticut, the Honorable Massimo Radicati; editorial director of *L'Idea* magazine Tiziano Thomas Dossena; Miss Puglia USA 1998 Donna Chinaglia; and editor in chief of *L'Idea* Leonardo Campanile. Below, the organizers, visiting politicians, and a performer pose after a Miss Puglia USA event in 1999. From left to left are Leonardo Campanile, comedian Gianni Ciardo, Gianvito Bottalico, Vincenzo Cristino (mayor of the Town of Mola diBari), Tiziano Thomas Dossena, and Giovanni Russo (chairman of Miss Puglia USA). (Both, courtesy of Tiziano Dossena.)

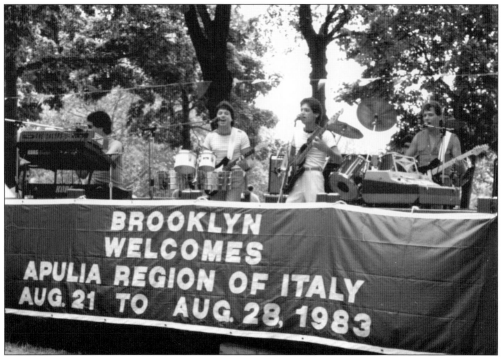

The Brooklyn-based band the Caleps performs for the Apulia Region Feast in Queens, New York, in 1983. That same year, the group was invited to perform for Pres. Ronald Reagan following one of his speeches in Miami, Florida. Their charitable events included the Jerry Lewis Telethon and the Feed the World Foundation. (Courtesy of Liana Amodeo.)

On Bay Thirteenth and Eighty-Sixth Streets, youngsters Joseph Randazzo (front) and Anthony Rozza play on a Vespa before playing Little League baseball and soccer in 1985. The Brooklyn Italians Soccer Club has been regarded as one of the most successful semipro teams in the United States, with a history that stretches back over 60 years. In 1949, the Brooklyn Italians Soccer Club was born. The club became one of the earliest teams in the New York City area, competing in local leagues against rival social clubs. (Author's collection.)

Four

PATRIOTS AND HEROES

The absorption of immigrants into mainstream American life was helped by their steadfast loyalty during World War II and the wars that followed. Over 500,000 Italian Americans served during World War II. They distinguished themselves in every branch of the armed services, and at least seven received the Congressional Medal of Honor. For some, it was the first opportunity to see the towns of their ancestors. In subsequent wars, men like Fr. Vincent Capodanno, son of Brooklyn Italian immigrants Vincent and Rachel Capodanno, proved to be unsung heroes. On September 4, 1967, Father Capodanno was killed on a battlefield in Vietnam while providing spiritual care and comfort to Marines under fire. Men like Cavaliere Ufficiale Joseph Sciame, who lived across from the Church of St. Malachy in Brooklyn, served in the US Army. He has been a patriot and a staunch supporter of Italian American rights in his various roles. Since 2011, he has chaired the Conference of Presidents of Major Italian American Organizations, with some 40 groups. Of course, the 266 Brooklyn residents who perished on September 11, 2001, must be mentioned. Many among them were Italian American service providers. In 2010, Brooklyn-born Salvatore Cassano took the helm as the New York City fire commissioner. He served until 2014. "Valor is a gift," Carl Sandburg once said. "Those having it never know for sure whether they have it until the test comes." Italians have unremittingly passed the test.

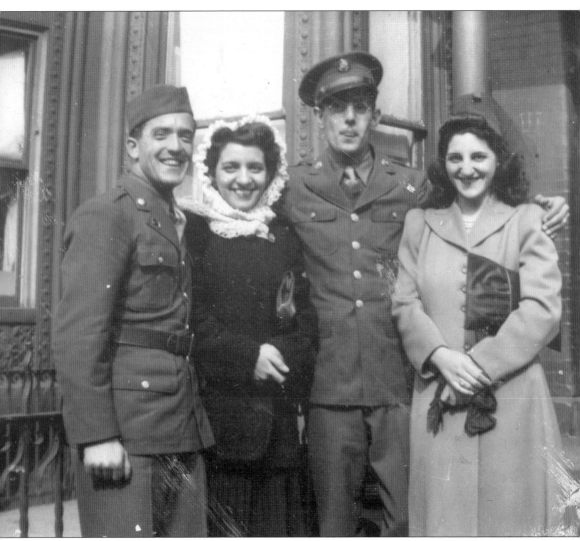

Proudly standing with their soldier fiancés who were on leave in 1942 are two smiling sisters. The couple at left are Mary LaMonica and her sweetheart, Vincent Basso. Posing with them are Emanuella LaMonica and Giovanni DeCastagna. Marriages came after the war. Before they became mothers, the girls worked in stores and then had to give up their positions. After World War II, Vincent was a ballroom dancer and worked at Radio City Music Hall, while John worked as a taxi driver. (Courtesy of Diane Campione.)

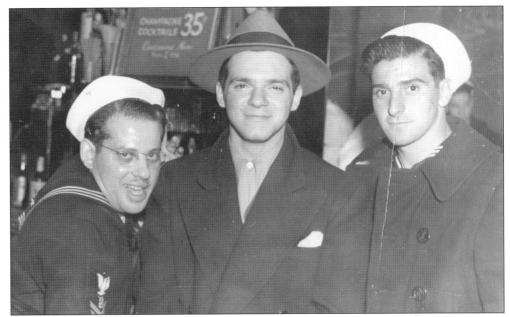

Ed Lembo (with the fedora) gets together with two Navy buddies, Larry Silvestri (right) and another pal, during their leave. The champagne cocktail in the Bay Ridge bar, advertised for 35¢, was calling their names. Lembo never made it into the service because of the burns he sustained to his legs when lighting Christmas trees on fire for fun with buddies in the vacant Bensonhurst lots, where kids got into mischief. He was classified as 4F. Instead, he drove trucks and worked in the family printing business until 1970. He then drove a transit bus through the streets of Brooklyn for 10 years. Not giving up his love of driving, he later became a truck driver for the *Wall Street Journal*. After his service, Silvestri served as a detective in the narcotics squad in Brooklyn. After retirement, he pursued a career in acting. Among the many roles he played was the part of a cop in Goodfellas—the cop played a cop. (Courtesy of Joanne Mantovani.)

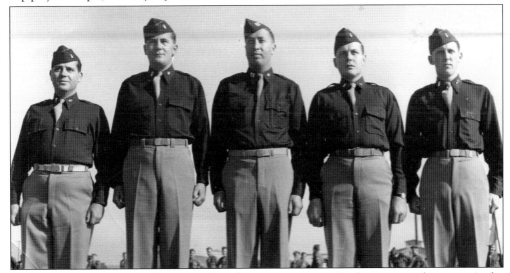

America supported its armed forces and has shown great respect for those men and women. At the end of World Wars I and II, those in uniform returned home from Europe to ticker-tape victory parades, marching bands, and speeches. (Courtesy of JoAnne Jarush-Colombo.)

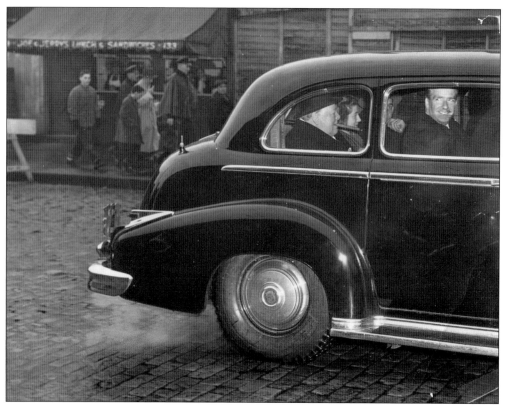

Winston Churchill, British prime minister, is in a car opposite Joe & Jerry's Italian Luncheonette on Fifty-Eighth street around 1942. Churchill arrived by ship from Great Britain at the Brooklyn Army Terminal and then traveled to Washington to seek help from President Roosevelt from the intense bombing in England from Nazi Germany. Lady Randolph Spencer-Churchill, his mother, was born in Brooklyn. (Courtesy of Jerry Montana.)

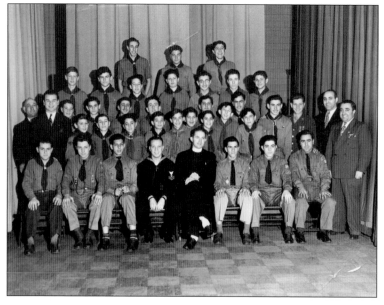

The Boy Scouts of America organized troops through local churches. In the 1940s, some scouts operated a messenger service for the Office of Civilian Defense. They also collected aluminum and books, planted trees, and raised money for war bonds. (Courtesy of Saint Finbar Catholic Church.)

DC 13 106 A=

N. WA25 (529) 46 GOVT 6 EX CK US DELY OR OL CHG= DX WASHINGTON

MR LORENZO GAGLIARDI=

2113 AVE Z (BROOKLYN NY)=

1943 FEB 13 AM 8 51

THE SECRETARY OF WAR DEISRES ME TO EXPRESS HIS DEEP REGRET THAT YOUR SON PRIVATE JOSEPH P GAGLIARDI HAS BEEN REPORTED MISSING IN ACTION IN THE NORTH AMERICAN AREA SINCE FEBRUARY 2 PERIOD ADDITIONA INFORMATION WILL BE SENT YOU WHEN RECEIVED=

ULIO THE ADJUTANT GENERAL.

2

On February 13, 1943, Lorenzo and Anna Gagliardi opened their door at 2113 Avenue Z to find an unwelcome messenger boy. Their son, Pvt. Joseph P. Gagliardi, was missing in action. Although not the definitive word, it was devastating. Two months and three days later, it was official. Enemy action in the North Atlantic had caused the death of their son. The formal letter from Major General Ulio had darkened their world. The ship their son was on, the *Dorchester*, had been torpedoed only 150 miles from its destination, an American base in Greenland. Along with Joseph were four chaplains who gave up their life jackets to men without any. The ship went down as the four chaplains linked arms and prayed on the slanting deck. (Both, courtesy of Elizabeth Capelonga.)

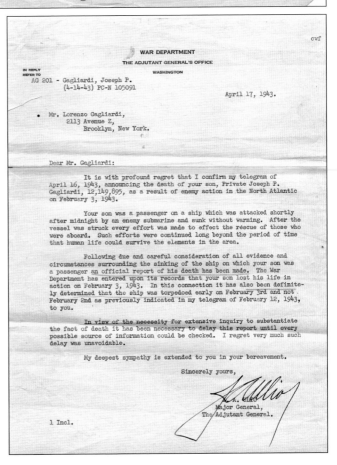

cwf

WAR DEPARTMENT
THE ADJUTANT GENERAL'S OFFICE
WASHINGTON

IN REPLY
REFER TO
AG 201 - Gagliardi, Joseph P.
(4-14-43) PC-N 105091

April 17, 1943.

Mr. Lorenzo Gagliardi,
2113 Avenue Z,
Brooklyn, New York.

Dear Mr. Gagliardi:

It is with profound regret that I confirm my telegram of April 16, 1943, announcing the death of your son, Private Joseph P. Gagliardi, 12,149,895, as a result of enemy action in the North Atlantic on February 3, 1943.

Your son was a passenger on a ship which was attacked shortly after midnight by an enemy submarine and sunk without warning. After the vessel was struck every effort was made to effect the rescue of those who were aboard. Such efforts were continued long beyond the period of time that human life could survive the elements in the area.

Following due and careful consideration of all evidence and circumstances surrounding the sinking of the ship on which your son was a passenger an official report of his death has been made. The War Department has entered upon its records that your son lost his life in action on February 3, 1943. In this connection it has also been definite-ly determined that the ship was torpedoed early on February 3rd and not February 2nd as previously indicated in my telegram of February 12, 1943, to you.

In view of the necessity for extensive inquiry to substantiate the fact of death it has been necessary to delay this report until every possible source of information could be checked. I regret very much such delay was unavoidable.

My deepest sympathy is extended to you in your bereavement.

Sincerely yours,

Major General,
The Adjutant General.

1 Incl.

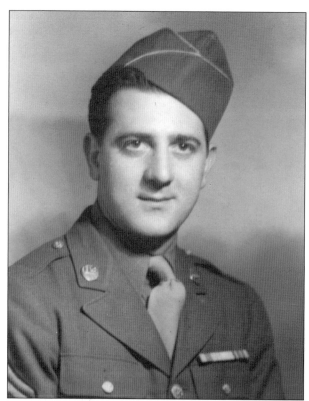

On May 4, 1943, Pvt. Joseph P. Gagliardi of the US Army Air Corps was posthumously awarded the Purple Heart for making the supreme sacrifice in defense of his country. He was 19 years old. (Courtesy of Elizabeth Capelonga.)

The Catholic Sea Cadets of Saint Finbar Church, seen here around the 1950s, were a proud group of youths. This junior cadet program introduced boys to leadership. The benefits to its cadets were both tangible and intangible. According to church officials, cadets felt pride, camaraderie, respect, and honor through their experience in the program. (Courtesy of Saint Finbar Catholic Church.)

Radio operator Jerry Falco sent a photograph of himself home to his parents during the war years of 1942 and 1943. Ham radio operators contributed enormously to the war effort by helping to train civilians in the proper and efficient operation of radio equipment and joining the service to apply their skills to the task. (Courtesy of Joanne Mantovani.)

Hello ma, Hello Pa —

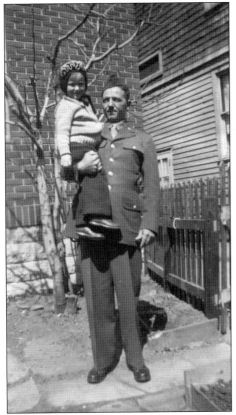

Serafino Mongiovetto should have been exempted from service; he was over the draft age and the only son and supporter of his widowed mother. But the Army was desperate. His mother kept a flag in her window to show her support and to let everyone know her son was serving. The dreaded telegram arrived. He was missing in action. Made a scout, he was put on the enemy lines, captured, and became a prisoner of war. Released at the end of the war and severely emaciated, he was sent to Saranac Lake, New York, for rehabilitation. Once home, he sucked down raw eggs to get his strength back. By 1955, he returned to Italy, and this time, he bought a farm, found a wife, and married. He never returned to Brooklyn. This photograph shows Serafino on leave, holding his niece Barbara before being captured by the Germans. (Courtesy of Barbara Pascarella.)

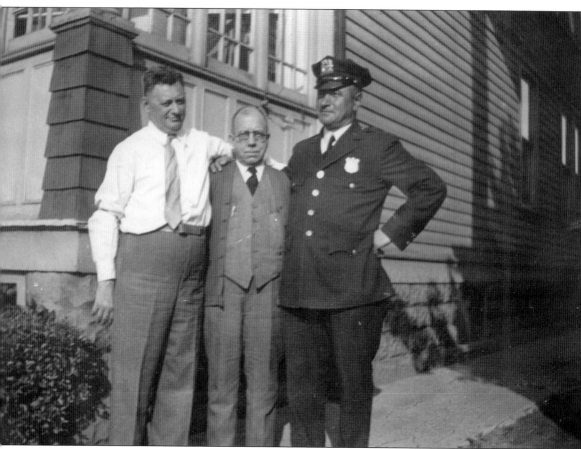

When Francesco Eduardo Muratore immigrated in 1885 at the age of 11, patrolmen were mainly Irishmen. In 1935, it did not stop Muratore from joining the police force. Known as "Eddie the Cop" to his Bensonhurst neighbors, Muratore was stationed in Flatbush. After World War II, prospects for Italian Americans improved as the country witnessed their performance as servicemen. The GI Bill gave many the opportunity to go to college, and it wasn't long before the women followed. (Courtesy of Barbara Pascarella.)

From Postmaster

PENALTY FOR PRIVATE USE TO AVOID
PAYMENT OF POSTAGE, $300

BROOKLYN
N. Y.
21
1942

POSTMASTER:
If this article is undeliverable
as addressed, endorse with reason
for nondelivery as directed in
the instructions.

Registered No.

F 99670

DELIVER TO ADDRESSEE ONLY

Do not deliver to any address other than that originally
placed on this article by the sender.

Do not forward to any other post office for delivery.

NAME *Gemma Belloli*

ADDRESS *8799 - 19 Ave.*
Bklyn, N.Y.

Instructions to Delivery Employee:
Before delivery of this article to addressee—
(1) Compare photograph inside.
(2) Ask for production of Alien Registration
Receipt Card.

16—26150-1

Gemma Di Pietro and Alberto Belloli arrived in 1906 and settled in the Little Italy section of Manhattan. Concerned about their daughter's asthma, the family moved to the Bath Beach section of Brooklyn for the fresh air of the country. On February 21, 1942, Gemma's failure to become an American citizen brought her under suspicion of the government as an enemy alien during World War II by President Roosevelt's Executive Order 9066. Posters were hung in post offices telling Americans not to speak Italian, German, or Japanese—the enemy languages. (Both, courtesy of Marie Fioriglio.)

RIGHT INDEX FINGER

This Alien Registration Receipt
Card should be sent to the Alien
Registration Division, Department
of Justice, Washington, D. C., (1) if
it is found; or (2) if the person named
hereon departs from the United
States, or becomes naturalized, or
dies.

her
+
mark

Gemma Belloli
(SIGNATURE OF REGISTRANT, OR PERSON REGISTERING THE ALIEN)

Wit J Frank
1964 nostrand Bklyn N.Y.

ADDRESS REPORTS—Read Carefully

The Alien Registration Act, 1940, requires all resident aliens
to report each change of address within 5 days of such change.
Other aliens, for example: Visitors, students, and others not ad-
mitted for permanent residence in the United States, must report
their address every 3 months whether they change their address
or not. Prepared forms for such address changes and reports
may be obtained at any post office. A penalty of fine and im-
prisonment is provided by law for failure to make the required
reports. Address letters and reports to the Alien Registration
Division, Department of Justice, Washington, D. C.
When reporting, give both your number and name.

U. S. GOVERNMENT PRINTING OFFICE 16—16416

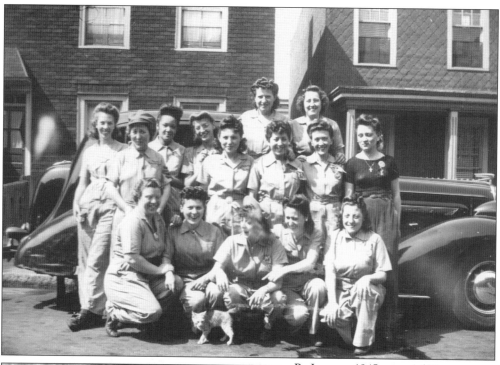

By January 1945, over 4,600 women were employed by the Brooklyn Navy Yard in production work. After the war ended, almost all of these women were laid off within six months. (Courtesy of JoAnn Colombo-Jarush.)

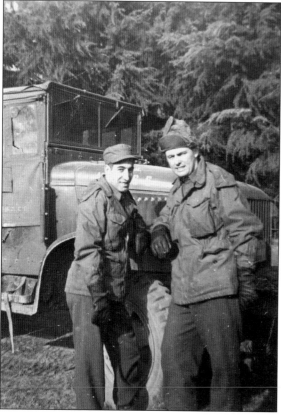

During the Korean War, Sam Maffeo (left) sent this photograph home to his wife, Frances, showing off his new "Cadillac." (Courtesy Andrea Maffeo.)

At the age of 20, Aldo Mancusi (second from right) went into the service during the Korean War. Unlike other 20-year-olds, he had vast automobile, mechanical, and electrical knowledge. He was not sent to the front lines, but to Officer Training School. Of the $129 a month he received, he mailed $100 home to his father every month. (Courtesy of Commandatore Aldo Mancusi.)

In the winter of 1973, in Williamsburg, four men held up and terrorized a dozen hostages inside John and Al's Sporting Goods. The situation lasted 47 hours. Co-owner Jerry Riccio (pictured) was instrumental in freeing the hostages. While the gunmen were distracted, Riccio carved a hole through a plaster wall that led the hostages to a hidden staircase and up to the roof and freedom. After this incident, new procedures were codified in the department's hostage-negotiating training program, begun later that year. Jerry Riccio's daughter Jessica, a lifetime Bath Beach resident, is the principal of Public-Intermediate School 163, the Bath Beach School. (Courtesy of Jessica Riccio.)

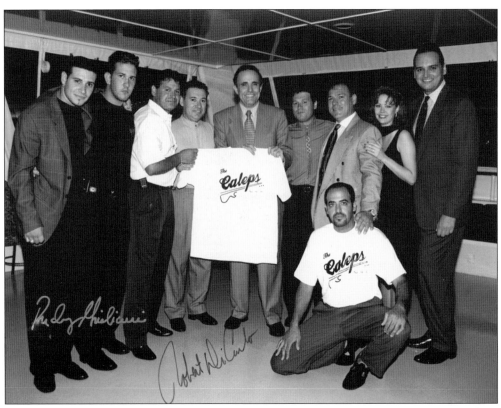

Musical group the Caleps pose with Mayor Rudy Giuliani (center) and state senator Robert DiCarlo and his wife (far right) on a New York City dinner cruise. Giuliani, the son of working-class parents, was born in East Flatbush and served as mayor from 1994 until 2001. He was widely praised for his leadership in the wake of the September 11, 2001, terrorist attack on the World Trade Center. Brooklynite Robert DiCarlo served in the state senate from 1993 to 1996. (Courtesy of Liana Amodeo.)

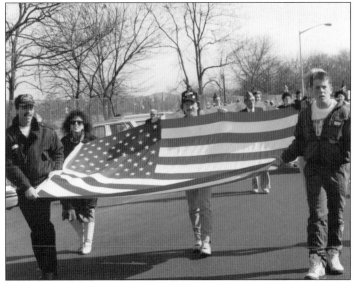

Members of the Federation of Italian American Organizations march through Bensonhurst and Bay Ridge in support of the troops. Among members of the organization are Figli Di Santa Rosalia Inc., New York Vizzinesi Association, Calabria Regional Association Inc., Castellammare del Golfo USA, and the Enrico Caruso Museum of America. (Courtesy of the Federation of Italian American Organizations.)

Italian American organizations have marched in support of veterans and in celebration of Columbus Day and other patriotic endeavors throughout the years. Eighty-Sixth Street closed to allow parades and a motorcade through the thoroughfare. Additional organizations include the Columbia Association of the NYCPD Inc., the Columbia Association of New York City Transit Authority Inc., the Donne Italo-American Ltd., and the Brooklyn/Staten Island UNICO. (Courtesy of the Federation of Italian American Organizations.)

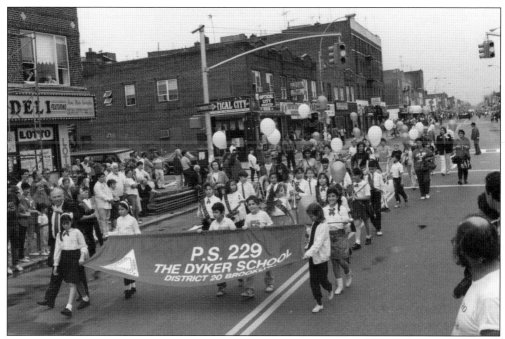

Public School 229 students and parents march in the Columbus Day parade. The stores on Eighteenth Avenue represented an array of Italian specialties, from imported Italian shoes to the SAS Italian record store. Other organizations that participated in marches include Sciacca Social Club, Società Figli di Ragusa, Societa Maria SS Di Casaluce, Society of the Citizens of Pozzallo, and Società S. Calogero di Torretta. (Courtesy of the Federation of Italian American Organizations.)

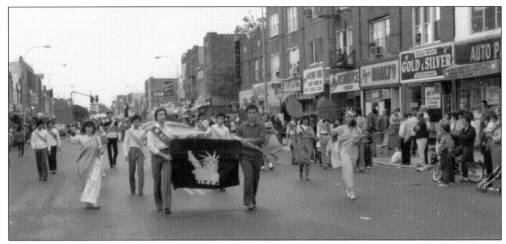

As a teenager in 1979, during her first years in America, Palma Mingozzi proudly displays her patriotism dressed as Lady Liberty in the annual Columbus Day parade in Bensonhurst. Mingozzi became an accomplished artist, writer, and talk show host. Her poetry is written in Italian and English. (Courtesy of Palma Mingozzi.)

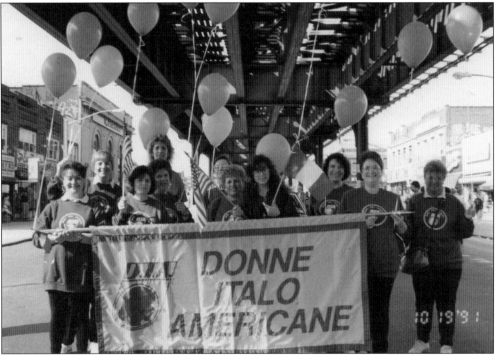

Marching in the Brooklyn Columbus Day parade in 1991 are the women of Donne Italo American. Donne Italo Americane (DIA) was founded to give Italian American women a voice in the Bensonhurst community, provide a network of support and further awareness and career opportunities for its members, and promote cultural and social activities. DIA was the first female group to be part of the Federation of Italian American Organizations. In the late 1980s, Annamaria Gallo saw the need for female involvement, and together with three friends—Lucretia Di Giallonardo, Josephine Frazzetta, and Enza Messina—founded the organization. (Courtesy of Donne Italo Americane.)

Five

THE NEIGHBORHOOD

Going from neighborhood to neighborhood, one will discover Italian American influences in Brooklyn from the last century. They include everything from food to literature to construction and politics. The country turned to Brooklyn for industrial needs. However, beginning in the 1950s, people started fleeing Brooklyn for Queens, Long Island, Staten Island, and New Jersey. At the same time, Italian families moved to Bensonhurst and Gravesend. In 1957, Brooklyn's pride was dealt a harsh blow by one particular departure: the Dodgers moved to Los Angeles. It was a devastating blow for all Brooklynites.

There is no question the city was in turmoil during the 1970s and early 1980s. But, by the end of the 20th century, Brooklyn began to spring back to life. Today, Brooklyn is called home again by many thriving immigrant communities. Italian descendants still monopolize real estate in some neighborhoods, but the enclaves have grown smaller, and the second and third generations mostly visit. As new generations discover the beauty and diversity of Brooklyn, a yearning to reconnect with a world that had been lost and now has emerged over the past 30 years or so exists. With so many millennials taking an interest in their ancestral Italian roots, it is hoped that some of the beautiful traditions and customs and beliefs brought to America by their great-grandparents will resurface. Tourists may still flock to Manhattan, but locals know that Brooklyn attractions rank among the best of New York City's essential destinations. Moreover, with a century of immigrants living together, Brooklyn neighborhoods have demonstrated that the social boundaries between rival ethnic groups could easily be dissolved and even replaced by love. In certain Brooklyn neighborhoods, some street signs have been changed, added, or adapted as an honorary memorial to a prominent person or even an entire community. These modest monuments are potent reminders of esteemed individuals who played a role in their local community.

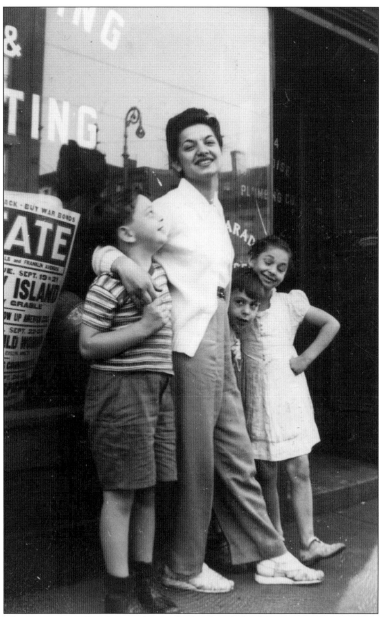

Members of the Prestininzi family stand outside the family building in Bedford Stuyvesant, where a sign encourages Americans to buy war bonds and go to the movies. Betty Grable appeared at the Kismet in the film *Coney Island*. The year was 1947. From the late 19th century and well into the 20th, Nostrand Avenue was considered by New Yorkers and Brooklynites alike the "Park Avenue of Brooklyn." The avenue and the streets that intersected it were home to doctors, lawyers, and entrepreneurs. Bedford Stuyvesant was Rose Prestininzi's quiet Italian neighborhood, where she attended Saint Francis High School for Girls and met Frank Serpico. Both were the offspring of immigrant shoemakers. Serpico became a New York City police officer in 1959 and served for 12 years. He reported and exposed corruption within the department. In 1971, he testified before the Knapp Commission. His life was dramatized in the 1973 film *Serpico*. (Courtesy of Rose Prestininzi.)

Like other Brooklyn high schools, Alexander Hamilton was named after a famous American in history or a landmark—Lafayette for the Marquis de Lafayette, Thomas Jefferson, Abraham Lincoln, and New Utrecht. Of course, Catholic high schools were named after saints. Alexander Hamilton was Cavaliere Ufficiale Aldo Mancusi's alma mater. Mancusi received the title of commendatore from the Italian government. The title is considered one of Italy's greatest honors. Mancusi's idol, Enrico Caruso, also had this title bestowed upon him. (Courtesy of Commandatore Aldo Mancusi.)

Gabriel Carbone (standing in back row, fourth from left) is among his fraternity brothers of Alpha Phi Delta and sorority sisters on a field trip to Staten Island. This group of students were all from Midwood's Brooklyn College. (Courtesy of Gabriel Carbone.)

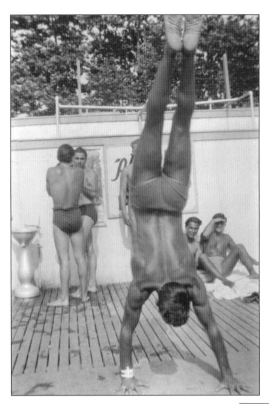

Young men gather at Ravenhall Baths, the most significant pool in Coney Island. The baths also had a four-wall handball court, a bar and restaurant, a private beach, chin-up bars, kiddie pools, and hundreds of rooms and lockers for seasonal and daily guests. One could conveniently rent a wool swimsuit and towels there. (Courtesy of Joanne Mantovani.)

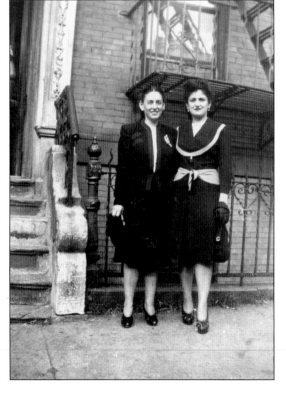

Lucy Granese (right) and a friend pose outside the stoop on Garfield Place in 1940. Rumor has it that Al Capone, who lived on the block as a child, may have stashed money in a vault somewhere on Garfield Place. In the 1920s, the area where the Capone family lived was referred to as "South Brooklyn," a rough and tough neighborhood, with no resemblance to the Park Slope of today. (Courtesy of Adele Mautschke.)

The lovely Lisa Mancusi poses for a photograph at the park by the Sixty-Ninth Street Pier in April 1952, before her husband leaves for service. In 1952, the average woman in America was married by 20 and looking forward to raising a family. Few continued with a career after children were born. (Courtesy of Aldo Mancusi.)

Placed on a crate to entertain herself, young Carmela Tringali with her Shirley Temple curls waits patiently while her great-aunt Nancy Nobile works inside her candy store at 7204 Thirteenth Avenue in Dyker Heights. This was one of many successful businesses the illiterate woman and her husband owned in addition to multiple apartment buildings. (Courtesy of Carmela Cave.)

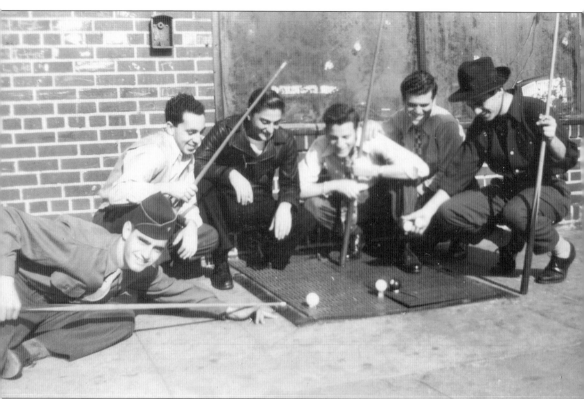

In 1945, after the war, a serviceman and a few buddies shoot pool over the cellar doors outside the poolroom on Fifteenth Avenue and Sixty-Ninth Street in Bensonhurst. Veterans were encouraged to continue wearing their uniforms in public and were well respected. (Courtesy of Joanne Mantovani.)

Marie Corticiano stands outside her building at 147 Sackett Street in 1940. Families resided above stores or in the rear apartments. This part of Brooklyn was known as Gowanus, Red Hook, or South Brooklyn, and was populated by a mix of immigrant families. A look at the 1910 census records for Sackett Street, Fourth Avenue, and the surrounding blocks shows families migrated originally from Ireland, Sweden, England, and predominantly Italy. (Author's collection.)

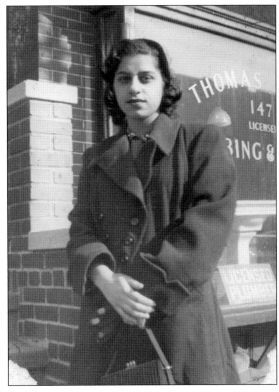

Teenage girls are hanging around on monkey bars at a Marine Park playground in 1956. Growing up, kids played kick the can, ringolevio, tag, man from uncle, and hide and seek, and when they got tired, they played marathons of Monopoly and Life on the stoop. When that got boring, they filled bottle caps with melted crayons that they melted with matches from the family smoker. At the park, the monkey bars and swings provided plenty of physical activity, as did hopscotch or jump rope. In the neighborhood in the 1960s, most kids came from blue-collar families. Many fathers had to give up a college education to go to work. They made their children believe they could be anything they wanted to be, but they could not cross Eighty-Sixth Street alone or take the subway into the city. Italian mothers were fiercely overprotective. (Courtesy of Annette Pensabene Marten.)

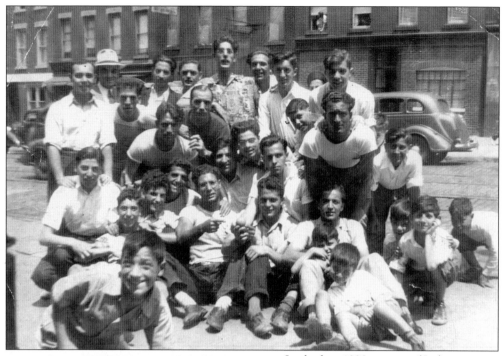

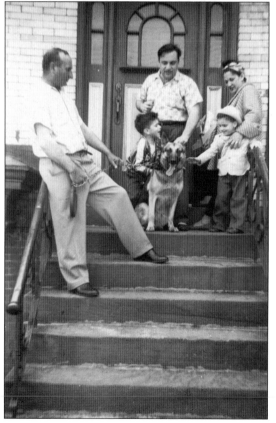

In the late 1930s, gangs of Italian boys of all ages gathered in the streets to play ball and other street games, and to horse around. A social club on Union Street hosted poker games. In the back row at center wearing a printed shirt is Giovanni DeCastagna. Standing at right leaning forward wearing a white T-shirt is Vincent Basso. The two best friends married sisters and served together in World War II. (Courtesy of Diane Campione.)

Italian American life in Bensonhurst once meant that families with young children lived side-by-side with relatives in the same building or within walking distance. This family has lived on the block of this house at 916 Sixty-Third Street for over 100 years. This photograph shows an uncle, cousin, godmother, brother, and Juno the dog. (Courtesy of JoAnn Colombo-Jarush.)

Annette Pensabene, with her boyfriend, Tom Marten, an Irish-German boy, sit on the top steps in their Sunday best after Mass and Sunday dinner. With them on Brown Street in Sheepshead Bay is a friend. Young people's contact with other ethnic groups contributed to Italians giving up some customs such as marrying their own. Most were eager to embrace and be identified with American society. "At first, my mom wanted me to marry an Italian, but she also fell in love with Tom," said Annette. (Courtesy of Annette Pensabene Marten.)

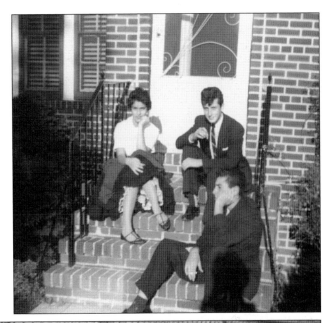

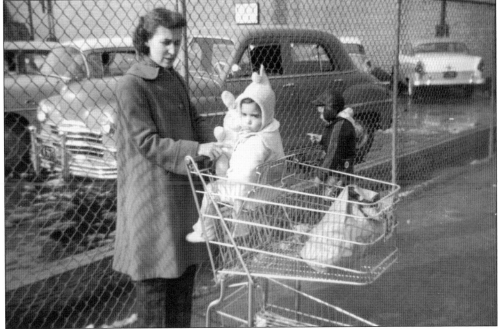

Before self-service grocery stores became popular, most women shopped in specialty shops, such as fruit stores and butcher shops. Others had items like milk, cloth diapers, and seltzer delivered directly to their doors. By the 1950s, supermarkets began to dominate, even providing large parking lots to encourage automobiles. The days of locally grown produce were over, and people, mostly women, picked out their items from shelves that were well stocked. No longer did the proprietor add up the tab on the back of a brown bag with a pencil he kept behind his ear. Cash registers did the job. Here, Ann Colombo is shopping with her two children, Janice in the carriage and Tom in tow, at the A&P at Fifth Avenue and Eighty-Seventh Street in Bay Ridge in 1957. (Courtesy of JoAnn Colombo-Jarush.)

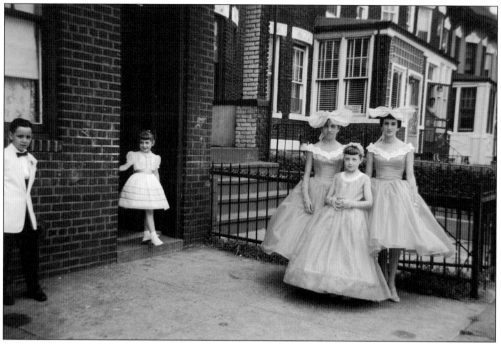

Too young for the bridal party, Philomena Marano smiles from the doorway of her Seventy-Fifth Street and New Utrecht Avenue home in Bensonhurst. In the bridal party are Philomena's cousin Alfred at left, and her sister Christine, in front of two more bridesmaids. Philomena, a talented artist, says she will always be a daughter of Brooklyn. Neighbors on the block look on, as a wedding is everyone's affair. (Courtesy of Philomena Morano.)

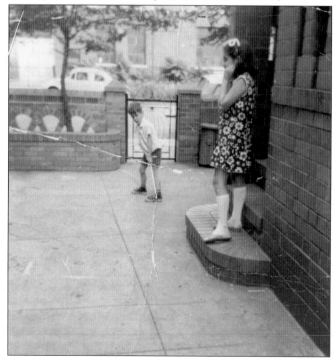

Though most of the houses on the tree-lined streets accommodated three or four families, Rosario Biazzo opted for the six-family building on the corner of Nineteenth Avenue and Cropsey Avenue. "Rents pay the mortgage," was his motto. Systematically, he added three more apartments in the basement, and with brick and cement, enclosed everything from the porch to the trees. In Brooklyn, it was not uncommon to have a cement garden, nor was it uncommon to do all the construction with the help of a few good friends. Frank Biazzo plays golf on a cement golf course while sister Marianna looks on. Imagination was crucial. (Author's collection.)

The Knights of Columbus was formed to render financial aid and assistance to the sick in 1882. The organization has become the world's foremost Catholic fraternal benefit society. The organization was named in honor of Christopher Columbus at a time when many Anglo-Saxon Protestants marginalized Catholic immigrants. The John Huges Council is located at 1305 Eighty-Sixth Street. (Courtesy of Saint Finbar Catholic Church.)

When Brooklyn Botanic Garden was founded more than a century ago in the Flatbush area, the New York City area was quickly being developed into a cityscape of buildings and paved roads. Creating a public garden was one way to ensure that some green space remained. Today, the garden has come to represent the very best in urban gardening and horticultural display. Gale Mileo poses in the garden in 1962. Below, Phyllis Mileo is pictured with her daughter Gale outside their Flatbush apartment building around 1956. (Both, courtesy of Gale Mileo D'Onofrio.)

When construction of the Verrazano Bridge commenced, homes between Gatlin Place and Dahlgren were razed in preparation for the highway leading to the bridge. As a result, it became a playground for local children. Parents, perhaps a bit more permissive at that time, let kids play with the bricks and twisted metal. As construction advanced and the mound of debris became a chasm, it was the perfect sleigh-ride venue. It was so deep that the faint of heart would shy away from it. "They certainly raised a hardy generation unafraid to take risks," said JoAnn Colombo, whose brother is second from right. (Courtesy of JoAnn Colombo-Jarush.)

Sisters Josephine, Mary, Gina, Antoinette, and Vita Loiacono pose in the backyard of the home their parents rented on Pitkin Avenue, East New York, in 1956. Years earlier, their father had come to America and worked for two years before calling over his wife and five daughters, whom he supported in Sicily. (Courtesy of Antoinette Loiacono Lordo.)

In March 1969, eight little boys gather to play on Eleventh Street in Park Slope. From left to right are (first row) Paul Iulo, David Corrao, Jay Martin, and Thomas Condello; (second row) Thomas Lally, Stephen Vardy, Christopher Erwin, Mark Corrao, and Anthony Corrao. The Corrao brothers wear matching sweaters, although Christopher's mom must have shopped in the same store. All the brick houses on the block were built around 1894. Joseph Esposito, a New York City taxi driver, and Nettie, his wife, purchased their home in 1948 for $3,000. Eventually, the house would be entirely occupied by the family. Joseph was able to pay back the mortgage in five years. Mark grew up to be a New York Police Department sergeant, having served 25 years, and Anthony works for the Department of Sanitation. David passed away in 1994. Members of the family still live in the original homestead. (Courtesy of Mark Corrao.)

A tradition that began in 1966 by Marion Castellano (seated fourth from left) continues to this day, with free concerts and dancing at the park at Bay Parkway and Cropsey Avenue. Marion served as grand marshal at the Miss Bensonhurst Pageant and was the beloved matriarch of Bensonhurst's rock 'n' roll community. (Courtesy of the Castellano family.)

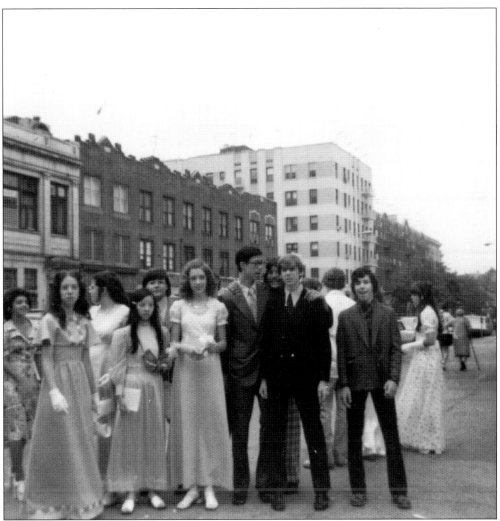

By the 1970s, Italian boys and girls had assimilated into the Brooklyn landscape, making friends with children of all nationalities, especially while attending Brooklyn's diversified public schools. This group of friends gather in Bensonhurst after graduating from Dyker Heights Intermediate School in 1973. Some have remained friends to this day, and maintained a friendship with their favorite history teacher, Harold May. (Author's collection.)

Italian American neighborhoods across the nation celebrated the accomplishment of Italy's national soccer team in the World Cup finals of 1982. These youngsters jubilantly display the Italian flag. Motorcades and parades marked the celebration in Bensonhurst. (Courtesy of Joseph DeSanto.)

When Ann Rose Murro Colombo spent the day at Coney Island with her childhood friend Philly and a gentleman friend during the 1930 season, the admission to the park was 10¢ on a weekday and 20¢ on weekends. Though posed in front of the equivalent of today's green screen in a model automobile, it was the subway that enabled millions of city citizens to reach the seaside resort for only 5¢. Coney Island was known as the "Nickel Empire;" however, the park went bankrupt in May 1933 at the height of the Depression. (Courtesy of JoAnn Colombo-Jarush.)

When Coney Island fell into steep decline during the 1980s, Brooklyn girl Philomena Marano co-founded the Coney Island Hysterical Society. The group was dedicated to the revitalization of the amusement area through artists' input. Here, Marano is painting a 2,300-square-foot Coney Island Hysterical Society mural, *Steeplechase Come Back*, in 1982. Below is *LONE/Coney Island Spiritual*, a 30-by-40-inch cut paper collage made in 1993 as part of her American-Dream-Land series. (Both, courtesy of Philomena Marano.)

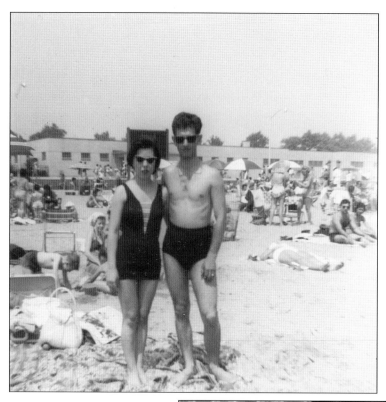

Newlyweds Vito and Connie Galifi enjoy the beaches of Coney Island on a weekend in the summer of 1958. The young couple lived in Bensonhurst, where Connie honed her dressmaking skills and Vito, an artistic baker, showed the locals what he was capable of creating in a pastry shop. The couple operated the successful Galifi Bakery for over 34 years. (Courtesy of Connie and Vito Galifi.)

True to traditional values, La Bella Marketplace has been a family-owned business for over 40 years. The Pesce brothers opened their first store in 1975 under the CTown name and continued to carry that name until 2008. In that year, they converted their Dyker Heights store into La Bella Marketplace and kept their Eighteenth Avenue store as a CTown. They opened in Staten Island in 2010 under the La Bella name. Pictured are Lenny Pesce (owner), Charlie Deluca (general manager), and Frank Pesce (owner). The third owner is Paul Pesce. This picture was taken at the October 1989 grand opening of CTown in Dyker Heights. (Courtesy of FPL Foods Inc.)

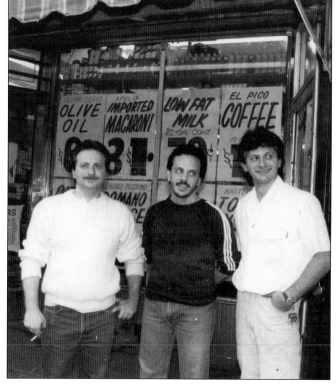

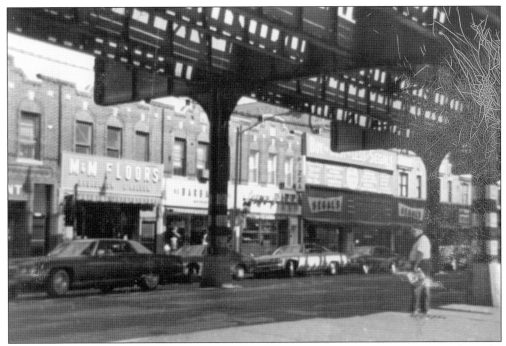

Once known only for shopping, the infamous Eighty-Sixth Street is now known as where the movie *Saturday Night Fever*, the iconic disco classic, was filmed. Other Brooklyn films include *The French Connection*, *Dog Day Afternoon* (with Al Pacino), *The Warriors*, *Brighton Beach Memoirs*, *Do the Right Thing*, *Jungle Fever*, and *Requiem for a Dream*. This large Brooklyn thoroughfare starts at the waterfront in Bay Ridge, crosses through Dyker Heights and Bensonhurst, and then ends near Gravesend at the border to Coney Island. The street is lined with every kind of store one would expect to find in a mall in suburban America, plus fruit and vegetable stands, hot-dog wagons, and pizzerias. (Courtesy of Lisa Arezzi.)

Long gone are the days when a handshake and a promise were enough to open a small business in Brooklyn. However, Kenneth Restrepo, former US Marine sergeant and his wife, Valerie, a third-generation Italian-American, were both born and raised in Brooklyn and know the secrets to success: hard work, determination, and honesty. That is what makes their Park Slope tattoo shop successful. (Courtesy of Valerie Restrepo.)

While tourists flock to Manhattan in droves, it takes a Brooklyn native (retired police officer Gaspare Randazzo, center) to show cousins Tiziano and Lulu DiMartino a favorite Brooklyn destination: Coney Island. The sightseers stand in front of Luna Park, one of the two major amusement parks. The other is Deno's Wonder Wheel, but it was not always the case. Once, there were legendary places like Steeplechase Park, Astroland, and Dreamland, but today, they are mostly memories with only a few remnants left. (Author's collection.)

When Joseph Randazzo married Jessica Helsel—of British, German, and Dutch descent—he wanted to share with her the Coney Island of his youth. The couple, living in Washington, DC, took a limousine ride through Luna Park in the summer of 2012 on their wedding day. As always, Coney Island is about making memories. The Dutch named the sandy ocean-side section of southeast Brooklyn Briiklyn Konijnen Eiland, or "Rabbit Island," as a large population of the furry mammals once inhabited the land along the pristine coastline. The name *Coney Island* still resonates with a sense of Brooklyn excitement. (Author's collection.)

Six

FAMILY AND FRIENDS

When one grows up Italian, they learn quickly that the most important things in life are celebrated or commiserated with family. All events, birthdays, anniversaries, Mother's and Father's Day, and even Sundays are reasons to gather, eat a lot, and catch up on family business. They grow up believing America is the greatest country in the world, but at the same time, they are intensely proud to be the children, grandchildren, and great-grandchildren of immigrants. That heritage makes them the men and women that they are today. As a child, Italians see this as perfectly normal until, as an adult, they learn what drastically different ideas non-Italians may have about dinner or family in general. With Italians, there is no distinction between the "nuclear family" and the rest of the family. Growing up immersed in the culture and traditions of their ancestor's homeland, they heard the stories of the old country, and for some, it meant carrying on traditions. Men like Raymond and Philip Leone, proprietors of Leone Funeral Home in Greenwood Heights, carry on the traditions of their parents, Anthony and Josephine, Italian immigrants who began the business in 1983. The proud family states, "We don't have a staff. We are the staff." The same year, in Bensonhurst, the Geraldi family opened Tasty Bagels, where Vincent, Joe, and Angel are always on the premises; their motto is, "Where the Difference is Homemade." A more modern entrepreneur is Ralph Grotto, who learned to cook with his grandfather at the age of eight in their Bay Thirty-Eighth Street home. In the tradition of the horse-and-cart vendors, Ralph now runs food trucks and specializes in his grandpa's riceballs. The "I Got Balls" trucks can be spotted at all the great feasts. Ralph, like most Italians, boasts, "Authentic Italian food from an authentic Italian!" Family, traditions, and values have not gone out of style. In the end, what made ancestors proud and satisfied, to a certain degree, still works in today's society.

Giovanna "Annie" Esposito Gagliardi arrived in 1906 and lived in Hoboken before moving to Brooklyn. Annie and her sisters presented themselves at the Triangle Shirtwaist Factory seeking a job on the date of the fatal fire. The sight of an Orthodox Jewish man with a long beard was so unfamiliar to them, they left the building frightened, saving their lives. While living in Hoboken, Annie became friendly with Dolly Sinatra, singer Frank Sinatra's mother. Her brother Atillio "Jimmy" Esposito married Angelina, Sinatra's aunt. The family grew. The typical Italian family that came to the United States was one in which the father was the key figure in the household. Everyone accepted that the father would make all the major decisions. But behind the scenes, the really influential figure in the family was the mother. She was directly concerned with raising the children and caring for the home. She resolved minor problems, and even though the father made the final decisions, she had a way of showing him what decisions he ought to make. (Courtesy of Elizabeth Capelonga.)

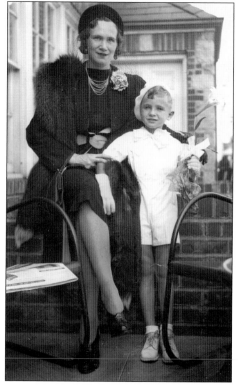

The family is the strongest Italian institution; it serves a source of protection and support. The Italian mother is the center, often holding families together. Here, Angelita Pizzini poses with her son Denny on his First Communion day in 1942. The future artist attended La Salle Military Academy in Oakdale, New York, from 1950 to 1953. (Courtesy of Denny Pizzini.)

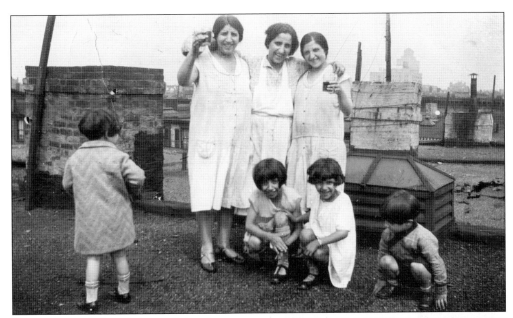

Economic need altered the traditional Italian family structure. When America's economy plummeted during the Depression, life began to change. Although the father was the unquestioned head of the household and the mother's duties were tied to home and children, wives and daughters were forced to seek work outside the home. The Castagna women are pictured enjoying some homemade wine on their roof in Park Slope. Maria (left) was a coat maker in a factory. (Courtesy of Diane Campione.)

Angelina LaRontonda feeds her daughter Marie in their Bath Beach home in 1946. Angelina worked for the telephone company and as a seamstress. (Courtesy of Marie Firiglio.)

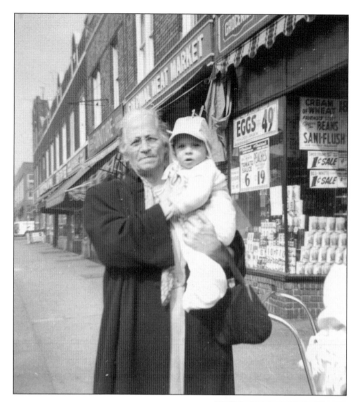

Grandparents' roles in Italian families have remained consistent. As in most families, the name symbolizes love, loyalty, and closeness. Here, a grandmother cares for her grandchild outside the family-owned Rawlston Grocery store on Eighteenth Avenue around the 1950s. (Courtesy of Raffaella DeSanto.)

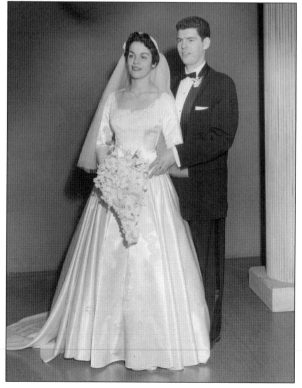

The wedding of Charles J. Sirey and Aileen Riotto occurred two times. The first was in December 1955 during a Brooklyn College break at St. Mark's Church in Sheepshead Bay. Charles was a returning veteran going to school on the GI bill. The couple divorced and remarried in the 1980s. Some things are just meant to be. (Courtesy of Aileen Riotto Sirey.)

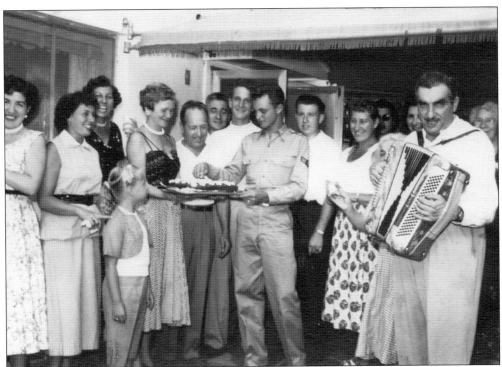

Returning home from Sampson Air Force Base, the family gathers for a celebration of the artistic Denny Pizzini. During his time in the Korean War, Denny (at center in uniform) painted portraits of pin-up girls on the noses of B-52 bombers. In later years, he created sculptures of the models, which he called "Denny Dolls." Below, under the arbor of grapevines, with music abounding, the family gets together for a Sunday dinner. (Both, courtesy of Denny Pizzini.)

Italian mothers of past generations may not have had the education they deserved, but they were involved in the process of educating the next generation. Most devoted all of their energies and talents to the house and family, never detracting from their stature or importance. The most important thing was to raise decent, hardworking, intelligent children. (Author's collection.)

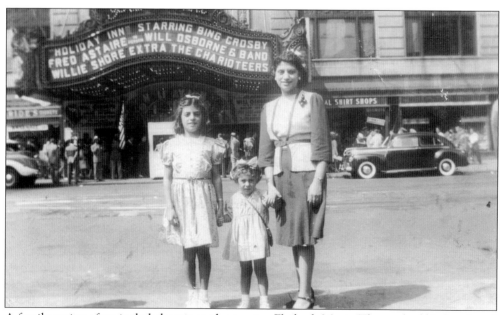

A family outing often included a trip to the movies. Flatbush Movie Theater had big bands and the last of the vaudeville acts, as did the Kenmore on Flatbush Avenue and the Paramount. (Courtesy of Rose Prestininzi.)

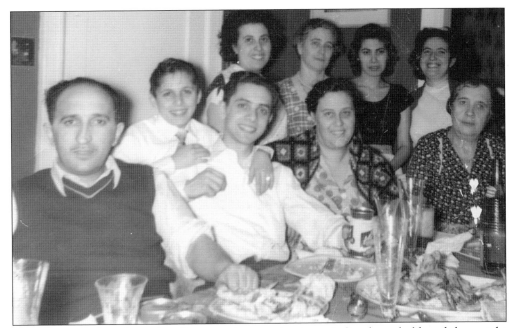

Ask any non-Italian about their first experience eating in an Italian household, and they might admit they thought the antipasto was the meal. Those lucky enough to join Italians at the table learn that before the first plate is served, the table may be set with baked clams, eggplant rollatini, garlic bread, fried calamari, mozzarella sticks, and stuffed peppers. Next comes the soup or pasta, salad, vegetables, and chicken, meat, or fish, or all three. Of course, all of these dishes are followed by fruit and whatever desserts guests bring, along with a bottle of wine. (Author's collection.)

Being the first family on the block with a television set meant sharing one's good fortune with the neighbors. One advantage of a limited amount of channels was that there were fewer disrespectful shows to disparage Italian culture and disgrace hardworking, honest men and women. (Courtesy of Diane Campione.)

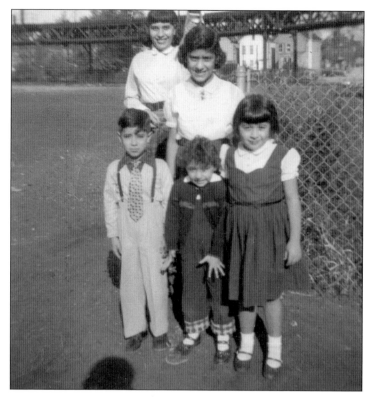

In 1954, the Loiacono family welcomed extended family from Sicily. From left to right are (first row) cousin Joe, cousin Concetta, and Antoinette; (second row) Gina and Josephine. In the background is the "El" train that ran from Pitkin Avenue to South Ozone Park shopping areas. Below, Loiacono family members pose with friends in the back kitchen of their family bakery on Pitkin Avenue in 1954. Typically, family-owned businesses meant keeping an apartment in the back of the store. (Both, courtesy of Antoinette Loiacono Lordo.)

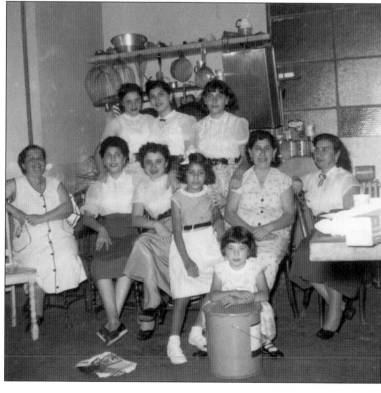

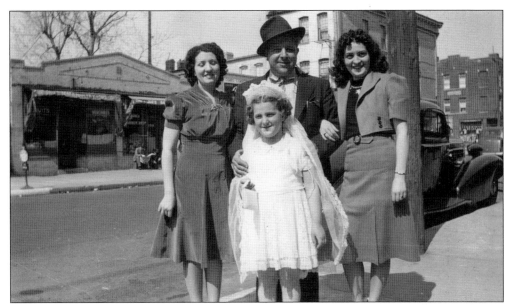

Big events were always memorialized by friends and family members. From left to right, Nancy Iannello, "Tom the butcher," and Ann DiLorenzo pose on Sutter Avenue in East New York in the 1930s with a neighbor's child receiving First Communion. (Courtesy of Geraldine Graham.)

By 1965, young couples like Carolina and Joseph Cutroneo had elegant weddings. The pair were united at St. Rosalia's Church, Regina Pacis Votive Shrine by Monsignor Angelo Cioffi. Family and friends gathered to celebrate the occasion. The bride's family is pictured here. (Author's collection.)

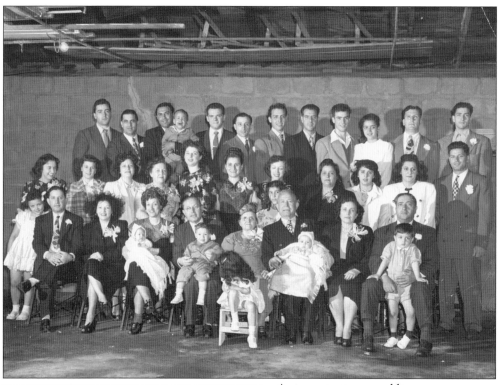

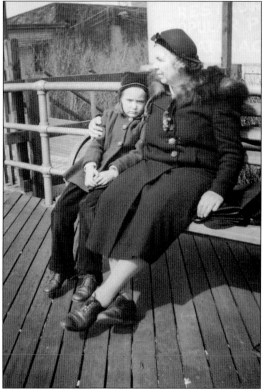

As important as a wedding was an anniversary. Maria and Andrew Falco are sitting in their garage with their entire family on the occasion of their 50th wedding anniversary. (The couple probably did not have a car, but the garage made an excellent location for the four generations gathered together in their home. (Courtesy of Joanne Mantovani.)

Maria Mongiovetto hugs her granddaughter Barbara on a chilly day in 1945 on a park bench in Coney Island. Maria arrived in 1911 and settled in Manhattan; the family eventually moved to Brooklyn, where the air was better for her child, who was sickly. Ultimately, the home she and her husband, Liovio, purchased became homestead to three generations. Extended families lived together or within a 10-block radius. It was not uncommon to live together in the same building, even after the children were married with families of their own. This trend continued up to the 1970s in Brooklyn. (Courtesy of Barbara Pascarella.)

Adele and Victor Granese assist their grandfather Andrea Pignataro in the basement of their family home. Winemaking was an annual ritual, as was making applesauce. Grandfather threw the seeds into the backyard, creating apple trees two stories high over the years. Below, Adele and Victor accompany Fiore Pignataro to LaGuardia airport after the accidental death of his longshoreman brother Joseph Pignataro. The accident opened an investigation of working conditions. The airport was named after New York's first Italian mayor, Fiorello LaGuardia, the son of Italian immigrants born in Greenwich Village in 1882. He was the first Italian American to successfully challenge the Irish dominance of New York City politics. (Both, courtesy of Adele Mautschke.)

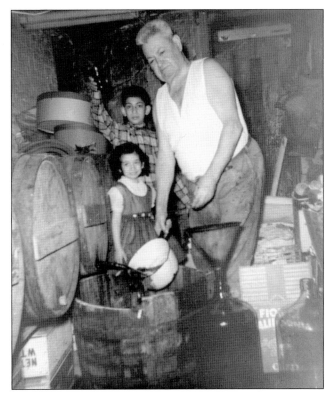

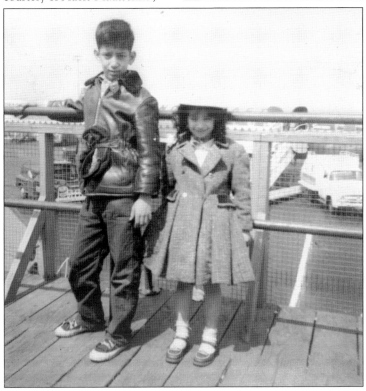

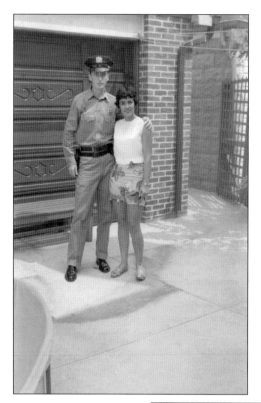

Tom Marten, in his police academy uniform, poses with his wife, Annette, outside their Batchelder Street home in 1963, proving that the mixed marriages (Irish, German, and Italians) were lucky: the couple remained married and loyal to each other for almost 50 years. Of course, as in most marriages, Italian customs and traditions dominated family life. (Courtesy of Annette Pensabene Marten.)

Unconcerned with the safety precautions of today, a family with four children piled into the rear of the family station wagon and rumbled about until their destination. It was often necessary to cram in double the car's capacity because relatives without vehicles always needed a ride. (Author's collection.)

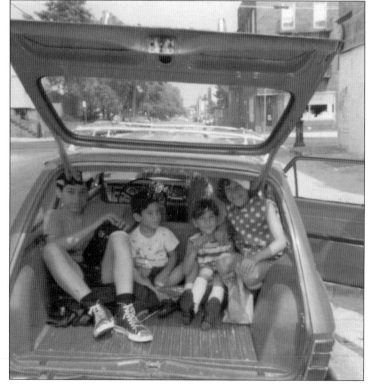

Half a block away from the 20th Avenue train station, Elena Arezzi awaits the arrival of her children from school at 3:00 p.m. Standing on the porch, she is respectfully greeted by all the children passing by on the block as the B train rumbles through the elevated station. (Courtesy of Lisa Arezzi.)

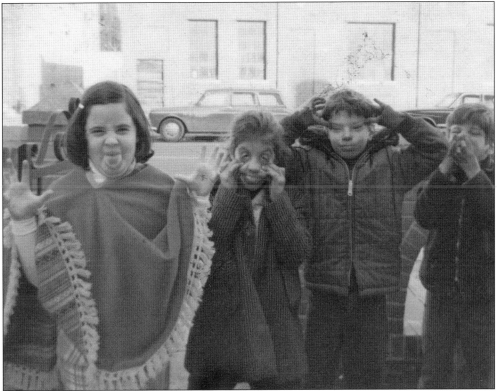

Never expecting parents to entertain children, four kids on the block make their own fun for the camera. The kids stand across from a gas station on 19th Avenue and Cropsey Avenue around 1970. Generations ago, it was a child's responsibility to entertain themselves with other kids on the block. From left to right are Maria Lisa LaRuffa, MaryJean Colletti, Vincent Favale, and Frank Biazzo. (Author's collection.)

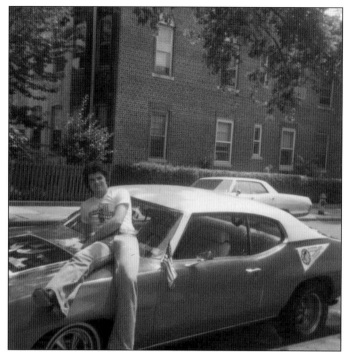

Camillo Messina, at 23 years old, lounges on his red 1972 Camaro on July 4, 1976. After his service in the US Marines, Messina briefly drove a Brooklyn bus before devoting a career to firefighting at Engine Company 330/Ladder 172 on 2312 Sixty-Fifth Street. During the bicentennial year, one's address may have said Brooklyn, but they were really from Bath Beach, Bensonhurst, Brownsville, Red Hook, Williamsburg, Bay Ridge, or another Brooklyn neighborhood. Many CB radio handles reflected the user's turf. (Courtesy of Enza Messina.)

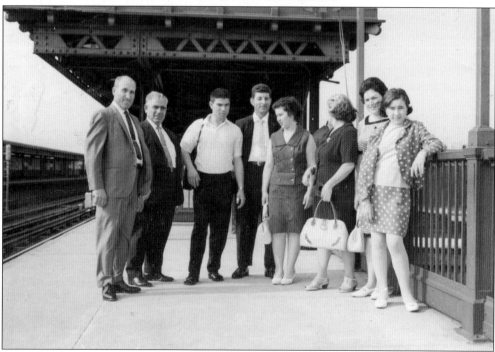

Four immigrant families that arrived between 1959 and 1965 proudly gather at the Eighteenth Avenue train station to attend the graduation of a cousin, Tony Piscitello, from New York University with a physics degree. The first woman from the left, Fortunata LoGelfo, found employment in the prestigious Saks Fifth Avenue as a ladies' alteration specialist. Her daughter Madeline (far right) sports one of her creations. (Courtesy of Madeline Taormina.)

The best time to go sightseeing in "the city" is when relatives come to visit. Unlike American vacationers, most stay for about a month. The DiMartino sisters, Sicilian immigrants, migrated to Belgium, where their father found work in the coal mines in 1956 and was able to support his 11 children. The author (center) enjoys the fun of Time Square with her Belgian Italian cousins in the 1990s. The universities that these ladies worked for closed during the summer months, allowing them to spend time in America with extended family in Brooklyn. (Author's collection.)

Discover Thousands of Local History Books
Featuring Millions of Vintage Images

Arcadia Publishing, the leading local history publisher in the United States, is committed to making history accessible and meaningful through publishing books that celebrate and preserve the heritage of America's people and places.

Find more books like this at
www.arcadiapublishing.com

Search for your hometown history, your old stomping grounds, and even your favorite sports team.

Consistent with our mission to preserve history on a local level, this book was printed in South Carolina on American-made paper and manufactured entirely in the United States. Products carrying the accredited Forest Stewardship Council (FSC) label are printed on 100 percent FSC-certified paper.

MADE IN THE USA